MW01285007

FOLK POTTERY OF THE SHENANDOAH VALLEY

Folk Pottery

OF THE SHENANDOAH VALLEY

by
WILLIAM E. WILTSHIRE, III

Introduction by
H.E. COMSTOCK

NEW YORK
E.P. DUTTON & CO., INC.
1975

In Memory of
WILLIAM E. WILTSHIRE, JR.

First published, 1975, in the United States by E.P. Dutton & Co., Inc., New York. / All rights reserved under International and Pan-American Copyright Conventions. / No part of this book may be reproduced or transmitted in any form or by any means, electronic or mechanical, including photocopy, recording, or any storage and retrieval system now known or to be invented, without permission in writing from the publishers, except by a reviewer who wishes to quote brief passages in connection with a review written for inclusion in a magazine, newspaper, or broadcast. / Published simultaneously in Canada by Clarke, Irwin & Company Limited, Toronto and Vancouver. / Printed and bound by Dai Nippon Printing Co., Ltd., Tokyo, Japan. / Library of Congress Catalog Card Number: 75-4221. / SBN 0-525-24800-5. First edition.

CONTENTS

ACKNOWLEDGMENTS

The author wishes to acknowledge the enthusiastic efforts of the many individuals who have worked together on this volume. For his introduction and history, special thanks are extended to H. E. Comstock, whose knowledge of Shenandoah pottery is unsurpassed and who has been so unselfish with his time and efforts. The support and encouragement of the staff of the Abby Aldrich Rockefeller Folk Art Collection have been invaluable. I especially appreciate the guidance of Donald Walters, who also wrote the foreword. Mrs. Elizabeth T. Lyon has provided many hours of faithful and patient assistance in the writing and typing of the manuscript. The outstanding photography is the result of the diligent work of Ronald Jennings, and graphic designer Raymond Geary is responsible for the exceptional visual appearance of the book. I wish also to express my gratitude to George Cruger and John W. Howard for their editorial assistance. In addition, I would like to acknowledge the assistance and cooperation of the following individuals and institutions:

INDIVIDUALS AND DEALERS

Carole Ambrogi
George O. Bird
Robert Bishop
John Bivins, Jr.
Dr. and Mrs. John F. Cadden
Dr. George Compton
Mary Cramer
Robert E. Crawford
Joann Crim
Gordon Crumpler
Mrs. Robert W. Day
Evelyn Deyerle
Dr. Henry P. Deyerle
Ann Freeman
Marshall Goodman
Mr. and Mrs. John Gordon
Harry Hartman
Mr. and Mrs. Boyd Headley
Mr. and Mrs. Neil Hevener
Mr. and Mrs. William Hooker

Frank Horton
Joe Kindig, III
Lawrence E. King
Dr. James V. Kiser
Barbara Luck
Mr. and Mrs. Roddy Moore
Arlene Palmer
Robert Rose
Beatrix T. Rumford
George Schoellkopf
Dr. Donald A. Shelley
Mr. and Mrs. J.G. Strädling
Raeburn Stanley
Michael H. Supinger
Peter H. Tillou
Henry I. Tusing
Dr. Franklin P. Watkins
Robert G. Wheeler
Kenneth M. Wilson
Dr. J.F. Wine

INSTITUTIONS

Abby Aldrich Rockefeller Folk Art Collection
Henry Ford Museum and Greenfield Village
Henry Francis du Pont Winterthur Museum
The Metropolitan Museum of Art
Museum of Early Southern Decorative Arts
New York State Historical Association
Philadelphia Museum of Art

FOREWORD

More than forty-five years have passed since the publication of A. H. Rice and John Baer Stoudt's groundbreaking study, *The Shenandoah Pottery*. While this useful volume aimed to be as comprehensive as possible, listing over two thousand works, an assessment in qualitative terms of the material presented there has been long overdue. Thus, new standards of taste and collecting interest have been set in William E. Wiltshire, III's careful selection of well documented and beautifully photographed specimens of Valley earthenware and stoneware, many of which have never before been published. As a result of this reevaluation, Mr. Wiltshire has furthermore revealed that many sculptural pieces previously thought to be purely Pennsylvania in origin actually were made in potteries of the Shenandoah Valley. Although concentrating primarily on the potteries of the northern portion of the Valley of Virginia, the author has taken into account the communication with potteries further to the north in defining the geographical scope of Shenandoah pottery.

Beyond having great visual impact, this publication also presents an informative introduction by H. E. Comstock, who offers fresh observations and insights into the identification, attribution, history, and technical background of Shenandoah pottery.

Viewed as folk or popular art, Shenandoah pottery—whether purely utilitarian, purely whimsical, or an amalgamation of both extremes—carried through the final years of the nineteenth century the earliest methods of manufacture and the earliest motifs of nineteenth-century popular culture. It is from the standpoint of the folk art tradition that the exhibition *Folk Pottery of the Shenandoah Valley* has been mounted at the Abby Aldrich Rockefeller Folk Art Collection in Williamsburg, Virginia (May 25 through October 4, 1975) to coincide with the release of this publication, which surely will become a useful tool in regional pottery studies.

Donald R. Walters
Associate Curator,
Abby Aldrich Rockefeller Folk Art Collection

INTRODUCTION

Folk art manifests itself in many different ways. As the basic artistic expression of the common man, folk art was created for the most part for economic gain, but was also often inspired by the love for a person, place, or thing. Such expressions are found in all areas of craftsmanship, and certainly one of the most interesting and primitively beautiful is early handmade pottery. Pottery played an important part in both the creative and practical aspects of American life and has now come to be highly regarded by most ceramics collectors and students of early American culture.

The heritage of the Shenandoah Valley in particular has been enormously enriched by its early ceramics tradition. Although most of the Valley's notable potters worked during the nineteenth century and their contributions came later than those of craftsmen of other areas of America, they can nonetheless be regarded as significant contributors to our folk art heritage. Prior to, as well as during, the nineteenth century, vast farmlands had attracted various groups of immigrants and farmers. Their need for crafted objects was fulfilled by itinerants and by farmers who were part-time craftsmen. Thus, most of the earlier products, especially pottery, were not marked and surviving pieces are therefore difficult to attribute as to maker.

One must remember that industry came late to the Valley of Virginia. The changing life styles, the rigors of the war years, the conglomeration of cultures, all went to produce an excitingly different area for the production of folk art pottery.

The Valley potters for the most part were immigrants or sons of immigrants. They were respectable, upstanding citizens who were considered by their fellow citizens as making necessary contributions to community life. Mainly of German descent, most had established themselves and their craft in other communities prior to settling in the Shenandoah Valley.

This publication will endeavor to give the collector, the historian, and the average reader a knowledge of certain aspects of folk art through the pottery produced by these craftsmen of the Shenandoah Valley. It should be pointed out, however, that the works featured here do not necessarily depict the average Valley ware. By and large, their products were utilitarian, and they depended on the sale of such pieces for their very livelihood. Many of the unique pieces illustrated here were made for family members, good friends, or business acquaintances, and were not intended for general sale. It is imagined that most were produced at the potter's leisure as expressions of love or gratitude towards special individuals. In all, it is hoped that this publication will confirm that, while areas of the northeastern and mid-Atlantic United States have long received the most concentrated efforts in pottery studies, the pottery of the Shenandoah Valley well deserves considerable and equal attention.

THE BELL POTTERS

As did most of the other craftsmen of the Shenandoah Valley, the potters migrated by way of the northern states, particularly Pennsylvania and Maryland. Much of the Valley folk art heritage is related to the southern movement of such immigrants, who were primarily German in heritage. Many came as members of religious groups, many were farmers, and some were solely craftsmen.

The latter was true of the Bell family, which moved from Hagerstown, Maryland to Winchester, Virginia. Peter Bell, the first of the noted Shenandoah potters, was born in Hagerstown (at that time called Elizabeth Town) on June 1, 1775. His father, Peter Bell, Sr., a commissioned captain of the local militia, moved to Hagerstown from Wiesbaden, Germany prior to 1767. It is not known if the elder Bell was a potter; he died on February 7, 1778.

Peter Bell conducted a pottery business in Hagerstown and sold earthenware as early as 1805. The town, known in the early nineteenth century for its earthenware products, had at least three different potteries during this period.

Because he had established an extensive clientele for his earthenware in the Shenandoah Valley, and most certainly due to the keen pressure of competititon in Hagerstown, Peter Bell decided to move to Virginia. This move occurred between April and September of 1824, and the Bell pottery existed in Winchester until the year 1845. Peter Bell primarily made utilitarian earthenware, such as pitchers, jugs, dishes, pots, mugs, jars, pipe bowls, and flasks, and he was particularly adept in the art of glazing. Very little of his work was marked, but those pieces that were bore the stamped imprint "P. Bell." His first stoneware was made in the Winchester pottery in 1832.

Peter Bell died in Hagerstown on June 18, 1847 at the age of seventy-two. He had six sons and four daughters. Three of the sons, John, Samuel, and Solomon, became well known as master potters and all are known to have potted at the Winchester site.

The oldest son, John, was one of the finest potters ever to have lived in the Shenandoah Valley. Born in Hagerstown on April 20, 1800, he moved to Winchester with his family in 1824. A very fine example of his work, the inkwell shown in Plate 3, bears a Winchester signature. One of his masterpieces, the lion in Plate 2, was most likely made in Waynesboro, Pennsylvania. What a superb contribution to American folk art! John Bell was a master potter even during his Winchester years, when he was in his twenties. In 1827, he moved to Chambersburg, Pennsylvania, where he operated a pottery for approximately six years. Yet, in 1833, Waynesboro, Pennsylvania became his permanent location. Here, he consistently produced pottery objects of high quality.

John Bell stamped his products with an imprint, the earliest being "J. Bell." Later the imprint became "John Bell," and finally, "John Bell, Waynesboro."

John Bell had six sons himself, five of whom worked with him in Waynesboro. After his death in 1880, John W. Bell, the eldest son, succeeded him as owner and manager of the Waynesboro pottery. John W. Bell's products, which were stamped "John W. Bell, Waynesboro, Pa.," were mainly utilitarian. After his death in 1895, his brother, Upton, assumed command of the pottery, producing the same types of wares as had his brother. His products were stamped "Upton Bell, Waynesboro," in impressed letters.

Samuel Bell, another of Peter Bell's sons, was also an extraordinary potter. He lived and worked with his father in Winchester until 1833, when he moved to Strasburg, Virginia, some eighteen miles south. Samuel bought a pottery that had been operated for some years by a German named Beyers, a producer of utilitarian wares. Drawing upon accumulated family experience, Samuel apparently was very successful in producing and in managing his own business. His products show the same high quality as did his father's and his brother John's. He, too, concentrated on utilitarian wares, but like John produced many molded specialty pieces, many of which were made specifically for friends and relatives. One of the earliest is the picture frame in Plate 10. Samuel Bell was particularly fond of making small animals, such as dogs and cats. He also lavishly adorned stoneware pieces with cobalt-blue tulips, leaves, and plant forms. His ware was marked with the stamp "S. Bell," sometimes in raised letters. Samuel owned and managed the pottery in Strasburg until his death.

In 1837, Solomon Bell, the third potter son of Peter Bell, moved to Strasburg, where he entered the pottery business with his brother Samuel. Solomon's abilities were equal to his brother's, and as time went on he in fact surpassed him, and for good reason. Wanting to make contact with his customers, Samuel allowed Solomon to manage production while he took over financial affairs and only worked at the wheel occasionally. It was at this time that the Bell pottery's stamp was changed to bear the name of Solomon Bell, who had become chief potter at the Strasburg Bell pottery. He was truly the backbone of the operation.

After Solomon's death in 1882, the Bell pottery began stamping its products "S. Bell & Sons, Strasburg." This stamp was employed until about 1904. After that date, marked pieces bore the simple impressed stamp, "Bell." This mark was used until the pottery was closed in 1908. After Samuel Bell's death, Charles Forrest Bell and his brother, Richard Franklin (Polk) Bell, were in charge of the Bell concern.

The most outstanding and most versatile group of potters in the Shenandoah Valley, the Bell family most assuredly made the greatest impact of all the potters in that area.

ANTHONY W. BAECHER

One of the single most masterful and skilled of the Shenandoah potters was Anthony W. Baecher. Baecher came to America in 1848 from Falkenberg, Oberfalk, Bavaria, where he was born in 1824. He was employed by a potter

in Pennsylvania for a brief period before moving into Maryland. There, near Thurmont in Frederick County, he entered into a partnership with one Jacob Lynn for the production of pottery. Baecher potted while Lynn conducted the business until 1868, when he constructed a pottery in Winchester, Virginia. For a while he divided his time between Winchester and Thurmont, but after 1880 he discontinued his interest in the Thurmont operation altogether and devoted all of his time to the Winchester pottery.

In the 1880 census of Frederick County, Virginia, Baecher is recorded as "A. W. Bacher," using the Germanic spelling of his name. However, like many of his fellow immigrants, he later Anglicized the spelling. Initially, marked pieces were stamped simply with "Bacher," but later he used the stamp "Baecher, Winchester, Va." He also signed many of his pieces in script, and dated many.

An extremely able and diversified potter, Baecher had learned his skills well, from the fine German masters of his day. Soon his influence spread, and one could see in others' products elements of his primitive, rococo designs. This was especially true of the Bell and Eberly groups, which in the mid 1880s began to use various appliqués of birds, flowers, and leaves, and other basic Baecher designs. It has been erroneously reported that Baecher never produced stoneware; it is true, however, that he produced very little in this medium.

Of all the Shenandoah Valley pottery products, Baecher's are today the most scarce and desirable. Their value is increased even further because of a low survival rate due to breakage and because his operation was small and his period of output short. For those collectors and admirers of pottery animals, in particular, Baecher is truly a champion. His work in this area is unique and extraordinary.

As a creator of folk pottery/sculpture, Baecher's contributions are indisputable. How can it be more properly expressed than in this statement by his son, as reported in Rice and Stoudt's *Shenandoah Pottery:* "His tastes were highly artistic and diversified; he was not only skillful but original, a creative genius in his trade. No mould or other formative device was known in his work; the naked eye and unaided hands moulded the thought of his creative mind into realities."

THE EBERLY POTTERS

Another significant group of potters of the Shenandoah Valley was the Eberly family. Jacob Jeremiah Eberly established a pottery in Strasburg in 1880. He was not a potter, but a farmer and businessman who found himself in the heart of one of the most active pottery centers in the eastern United States. He was able to hire competent local potters and various journeymen, and this ability to secure good craftsmen insured commercial success.

Eberly's son, Letcher, soon learned to make earthenware and was very instrumental in perpetuating their operation for a number of years.

The Eberly products were glazed in a similar manner to those of the Bell pottery, in all probability because one of Jacob Eberly's chief employees was Theodore Fleet, whose father had been responsible for glazing operations at the Bell pottery. The wares were of course utilitarian, though some forms were more ornamental in character, decorated with pseudo-rococo designs. Naturalistic appliqués of fish, seashells, lizards, hands, faces, bird wings, etc. were used.

The Eberly group was the most consistent of the Valley potteries in the marking of objects. The first stamp used was "J. Eberly and Co., Strasburg, Va.," then "J. Eberly and Bro., Strasburg, Va.," followed by "From J. Eberly and Bro., Strasburg, Va." The last marked pieces bore the stamped imprint "Eberly & Son, Strasburg, Va." The pottery ceased operations in 1906.

JOHN GEORGE SCHWEINFURT

One of the lesser known potters of the lower Shenandoah Valley was John George Schweinfurt, a native of Germany who was born in 1826. In the year 1850, Schweinfurt established a pottery in New Market, Virginia, where he mainly produced earthenware. He decorated many of his pieces with floral motifs similar to those utilized by Baecher. Unlike many potters of the area, Schweinfurt used a simple, one-glaze method. This was simply a matter of preference and should not be construed as a reflection on his abilities. He was a master at his art, and is perhaps best known for his production of miniature objects; surprisingly, many specimens still exist. Certainly, one of his most outstanding creations is the bank shown in Plates 58 and 59, truly a masterpiece of folk art.

Schweinfurt's major output included mainly earthenware crocks, pipes, toys, pitchers, cups, banks, inkwells, and flower pots. He rarely marked his work. His operation was small; in fact he is not known to have employed any other potters. The area that he served was also small, and was being served by other potters as well, primarily the Bells.

SHENANDOAH VALLEY STONEWARE

Although stoneware was being produced in America as early as 1730, it was about a century later before it was introduced to the Shenandoah Valley. In general, the best Shenandoah folk pottery is to be found in earthenware. Stoneware was more difficult and more expensive to work with, but the potters soon found that the native clay, with some refinement, was more than adequate.

Much of the stoneware bore brushed decoration in cobalt blue and sometimes manganese brown. The most highly decorated pieces are usually the large ones, three gallons and more. The distinctive purplish blues that are found almost exclusively on Valley stoneware are probably the result of a particular type of cobalt.

Very little existing stoneware has animal or human figural designs. Instead, most pieces bear tulips, various other plant forms, or crude C-scrolls. Occasionally one finds a piece with cobalt designs, such as the one shown in Plate 16, which certainly must rank as one of Solomon Bell's greatest achievements in stoneware. Peter, John, and Samuel were all producing stoneware in the early 1830s, and continued to work in both earthenware and stoneware.

Stoneware was the primary medium of the later Valley potters, with the exception of the Eberlys, who also worked in earthenware. Many fine pieces of American stoneware came from these craftsmen, the most notable of whom included Jeremiah Keister, Amos Keister, James M. Hickerson, Samuel H. Sonner, John H. Sonner, William H. Lehew, George W. Miller, W. H. Christman, and L. D. Funkhouser. All of these men worked at various times between 1870 and 1906.

SHENANDOAH POTTERY DESIGN

The Bells set design standards in the Valley during the early years of the nineteenth century, though not all their designs were entirely original. Many appear to have been derived from a variety of popular design motifs.

In general, Valley pottery products that were thrown on the wheel were relatively heavy, thick, and cumbersome. This is more true of stoneware than earthenware.

Earlier designs, especially of holloware, are more ovoid, with rapidly converging sides. As time went, on these pieces became squared off and the the sides more parallel.

Many potters showed certain peculiarities of design. Solomon Bell was fond of the lion motif, such as the vase with applied lion-head handles in Plate 12. This concept was copied by the Eberlys, who instead used a bird-wing motif. John and Solomon both produced full-bodied lion figures.

Another Solomon Bell trait is that the termini of applied handles, especially jugs, bear the imprint of a finger tip. The spouts of his stoneware jugs, rather than being plain, have a pleasing inverted lip, with an encircling rib-like projection equidistant between the lip and shoulder of the jug.

Bell handle types included grape clusters and leaves, molded dolphins, and many free-form designs.

Samuel Bell stamped many of his presentation pieces with small ovoid and circular markings. The Bells are the only Valley potters known to have used these small, football-shaped imprints. They vary in length, the smallest being about 6 to 8 mm., the largest about 20 mm. Many of the Bells used these small elliptical shapes to create floral units and to decorate the edges or rims of various products.

Solomon and Samuel Bell often incorporated the American eagle in their decorations. The birds that were commonly applied to Bell objects were not introduced until after Baecher moved into the Valley. Another Bell characteristic, as shown by marked examples, is the hand-shaping of flower pots, small vases, and crocks into the form of a bell.

Many of the Bell objects also have incised parallel banding, both horizontal and wavy. Similar incising can be found on Baecher pieces to some extent, and Eberly objects to a much lesser degree.

The scalloped and pinched rims of various holloware items, especially flower pots, were common to the Bells, Baecher, and the Eberlys. One often finds deeply incised vertical grooves on the rims of Bell and Eberly products.

Baecher designs are extraordinarily distinctive. He used some, though comparatively little, molding, in spite of his son's statement that "he used no mould or formative device."

Baecher applied leaves, flowers, and birds to his pottery pieces. Many of the applied birds have worms in their beaks, and many of the flowers are fully three-dimensional, with thin and fragile petals that were extremely vulnerable to breakage.

Baecher was also a farmer, which might explain his fascination with creating pottery animals. He made bird whistles, goats, bears, squirrels, chickens, and many more. In terms of design, he was the most diversified of all the late Valley potters. Seemingly never satisfied with a common pitcher or sugar bowl, he had an innate propensity for adding decorations and ornamental applications.

Many Baecher vases and other containers had double handles, which, though often plain, terminated in a pleasing curl. A distinctive feature of other handled objects, such as cups and pitchers, is that the terminus is fashioned to a sharp point, or a V-shape.

Most of Baecher's flower pots have a double-scalloped and pinched rim, a characteristic of many Valley pieces before his time. A design that he did introduce to the Valley, however, was the tapered-base, wall bouquet holder (see Plate 51), which was copied by the Bells but not by the Eberlys.

The Eberlys also introduced some highly original designs to the Valley during the late nineteenth century. Jeremiah Eberly hired journeymen of unusual ability. Of German and English origin, these potters taught Letcher Eberly and Theodore Fleet the art of making molds. The Eberlys, however, did not use molding processes as often as the Bells. On the other hand, study of their objects indicates that they probably used more clay appliqués than any of the other potters. The originality of the Eberly concept of decoration is expressed, for example, in a unique motif like the seashell, seen on so many of their objects. Small molded medallions with profiled heads in relief decorate many pieces (see Plate 46). Fish from the Shenandoah River were used as impressions for molds, and the Eberlys likewise made molds of snakes and lizards. They also applied lilies, roses, and daisies; small molded lions; and, as did the other potters, the ubiquitous molded birds. The Eberlys used molds for large pottery objects such as planters and flower pots. These pieces were most often multi-sectional. When united, they could reach the height of three or four feet.

Eberly handles differed in that they were usually of plain design. Some were molded. Many of the larger earthenware pieces had handles in the shape of a bird wing, a device unique to the Eberlys.

After a time, they discontinued the production of utilitarian stoneware and concentrated on earthenware. Stoneware at that time was being abun-

dantly produced in the Valley, and therefore competition was exceedingly keen. This condition, coupled with the fact that the Bells were the only other major producers of earthenware, resulted in the Eberlys' entering this more advantageous and specialized area of production, a situation that thankfully gave the Valley some very outstanding pottery.

The cabin scene by Theodore Fleet and the English journeyman Levi Begerly is no doubt one of the most imaginative pieces of American folk pottery sculpture. This unique form was conceived at the Eberly pottery in 1894, the occasion for its construction being the annual reunion of the "Johnnies" who had fought at the Battle of Fisher's Hill in September of 1864. As seen in Plates 40 and 41, there are some slight differences in the shapes of various parts of the two known cabin groups. These are particularly apparent in the chimney and in the placement of the human and animal figures.

VALLEY SLIPWARE

Ware displaying beautiful slip decoration is an outstanding though rarely seen category of Valley pottery. Peter and Solomon Bell seem to have produced the most slipware, as represented by the pieces shown in Plates 1 and 19. After the Bell pottery was operating under the name of S. Bell and Son, more slipware was produced; an example appears in Plate 18. The Bells produced slipware plates, bowls, cups, mugs, vases, and pitchers, using trailed and brushed slip designs in white, green, brown, and black. In trailing slip, the potter often modified a small bottle to receive a turkey or goose quill, thus creating a primitive type fountain pen with which to decorate. Slip was applied directly to the clay body and then glazed over with a clear lead glaze, which brought out the color of the clay itself.

The Eberlys also produced slipware articles, employing slip-decorated leaves and tulips on the same types of objects as did the Bells. Plate 43 shows a crude American eagle outlined in white slip. The opposite side of this vase also has numerous leaves drawn with slip. The Eberlys mainly used white but on occasion utilized a reddish-orange slip. The other Valley potters produced very little slip-decorated pottery.

VALLEY CLAY

The quality and quantity of the beds of native clay indeed favored Shenandoah Valley potters. Little refining was necessary beyond the removal of small stones, roots, and other debris. High in iron content, this clay would burn to a deep maroon color. This deeper red often distinguishes Valley redware from that of other areas. An additional advantage was that the clay lent itself well to the production of stoneware. Furthermore, the Valley potters were fortunate to have had access to an abundance of white clay, which was essential to the nature of Shenandoah pottery production during the nineteenth century.

BASIC VALLEY POTTERY PRODUCTION

Production methods in the Valley were similar to most other nineteenth-century pottery centers. The clay, after mining, was stored near the pottery. Normally it would be processed in or near the storage site and taken to the pottery to await use. It is apparent that some of the Valley potters processed, or "purified," their clay very little. Most of the better known potters, however, processed the clay by use of a horse-powered pug mill. The mill was designed to take clay that had been broken into lumps and had been cleared of major impurities. A horse was rigged to a long sweep arm that was in turn attached to cutting blades. The blades would be turned through the moistened clay until it reached a sufficiently homogeneous consistency. The clay would then be kneaded and worked into blocks of predetermined weight and size, then stored in a humid situation, usually under wet burlap bags. It was later broken and wedged into smaller balls, in quantities corresponding to the production of the day.

Holloware was most often produced, and this, of course, was "thrown" on the potter's wheel. The potter would often use forming tools, such as potter's ribs, which usually were made of wood and were fashioned into various curves and angles to aid in the shaping of the vessel. Specialized ribs were made for producing special rims, lips, grooves, and moldings, a practice that accounts for many of the similarities in Valley pottery.

If a spout or other adjustment to the basic form were desired, it was made while the object was still wet and before it was removed from the wheel head. The piece was sponged to give it its final smoothness, then removed by gently passing a wire under the vessel.

Handles normally were applied after the piece had dried sufficiently. The surface areas where the handles were to be located were roughened by scratching in a cross-hatched manner, and the handles were applied by thumb pressure and with the aid of small amounts of moist slip. Handles were most often formed free-hand, though some were fashioned in molds.

Elaborate molds, usually made of plaster, were used for certain forms, such as pitchers, candlesticks, animal figures, flower pots, and various appliqués. These molds were normally sectional, in two or more parts; the sections were united after being filled with slip and/or hand-pressured clay.

Sculptured ware was fashioned by various specialized tools. The potters relied on their own ingenuity in forming these pieces. Often in sculptured ware we find evidence of wire brushes being used to produce the effect of hair, such as seen on the dog in Plate 23. The mane and other hair effects on the lions were created by forcing wet clay through a piece of burlap.

Stamps and capacity marks were normally carved from wood. Marking was done after the piece was somewhat dry. The pottery objects were dried further and then were ready for glazing.

EARTHENWARE GLAZING TECHNIQUES

Shenandoah Valley glazes form an interesting and complex facet of our subject. This discussion of glazes deals initially with the distinctive mottled,

multi-colored glazes found on so many specimens of Valley earthenware of the last half of the nineteenth century, a glaze effect which has in fact become for collectors and students one of the signature characteristics of Shenandoah pottery. This multi-colored splash glaze has given many pottery products from the Valley of Virginia an easily recognizable identity of their own.

The execution of the mottled glaze, as it is found on specimens of Shenandoah pottery, was essentially a two-step process. Greenware earthenware objects, when in a biscuit (once-fired) state, were given an all-over coating of white slip, usually by dipping. White slip is merely a fine white clay mixed with water to form a cream-like consistency. Earthenware was sometimes sold in this slip-coated state without any additional glazing or firing.

The intermediate step in the creation of the characteristic mottled glaze was the addition of various green (made from copper oxide) and/or various brown (manganese dioxide) glaze configurations that were created by brushing, sponging, spattering, dipping, or dripping and by holding the object in different positions to control, in a general way, the flow and path of the colored glazes. In addition to these broad areas and spatterings of colored glazes on the white slip ground, one usually also finds small specks of color overall.

Sometimes, semi-accidental effects caused by the bleeding of the colored glaze into the white slip coat produced highly dramatic and decorative qualities. Many times, especially where the slip coating is very thin, the red body of the clay itself shows through, which has the effect of producing gradations of white, pink, and orangeish-red in the ground coat itself. It is in general the accumulated experience with, and balance of, controlled application and semi-accidental glaze effects which imparts the feeling of tremendous spontaneity to the traditional Shenandoah multi-colored glazes.

Almost anticlimactically, it seems, the final step in the process was an all-over coating of what is basically a clear lead glaze. The purposes of this final coating were to seal the object, making it impervious to liquids, and aesthetically speaking, to intensify and enrich the colored glazes in much the same way that a varnish does an oil painting. It should be noted at this point that some pieces were produced and sold with the colored glaze additions but without the final clear glaze coat. The resultant effect, as illustrated by the objects in Plates 12 and 13, was that of shiny colored glaze areas on a contrasting matte-finish white ground.

The more common procedure was to use a lead overglaze. The lead glaze was composed of lead oxide, a flux; kaolin, which is high in aluminum content and which would prevent the molten glaze from running or moving during the heating process; and silica, which, when combined with water in a finely ground or powdered state, gives the glaze its glass-like quality and appearance. Lead oxide was used as a flux partially for economic reasons; it lowered the fusion point of the glaze compound, therefore reducing the amount of heat necessary for fusion, and in turn cutting fuel and production costs. It is said that after the Civil War local boys would go out into the battlefields to collect lead bullets for sale to the potters.

In addition to the basic ingredients of this lead glaze, there were certain inherent natural impurities, such as iron, that were not filtered out and which appear usually as tiny dark brown specks in the glaze. Although the glaze was essentially clear, it did have, depending on the varying content of impurities and thickness of application, a slight yellowish tinge which had the end result of making the white slip undercoating appear yellow.

This otherwise relatively clear glaze enlivens the redware body itself and (especially as can be seen on the bottom of a piece where there is sometimes only partial coverage) makes those parts that are covered look shiny red, orange, or brownish; the color depends not only on the color of the clay itself, but, in addition, as we have stated, on the amount and nature of impurities.

Many purely utilitarian vessels created in the Shenandoah potteries merely received this lead glaze coating, often only on the inside, to seal them against liquids. The pottery produced by Schweinfurt is a good example of this simplest of glazing treatments. The Schweinfurt miniatures shown in Plate 60 not only illustrate basic lead glazing, but also display in some cases the variations, partially accidental, which could be obtained by regulating the oxidation/reduction atmosphere in the kiln during firing; the olive-drab tones and orange spots in the lead glaze in these examples are a result of kiln atmosphere. Pottery sculpture, like the figure in Plate 26, also was often simply lead-glazed in this fashion.

By contrast, color could be introduced intentionally into the one-step lead-glazing process by the addition of mineral pigments to the basic lead glaze. One example is the figure of a boy shown in Plate 4, which bears what is essentially a clear glaze with iron oxide used as a coloring agent; the result is a rich dark brown-to-black streaking glaze showing the orangeish body of the clay at the points of thinnest coverage.

The yellowish tinge in a final lead overglazing, which was previously discussed, can assist in the identification and distinction of certain Valley production.

Generally speaking, the Eberly glazing materials were less finely ground than the Bells', giving the Eberly glaze a less homogeneous appearance. Nevertheless, the Eberly lead overglaze was itself more refined and does not have to the same degree the yellow effect that is evident in the Bell overglaze. In addition, the Bells' yellow-tinged glaze often shows iron or manganese particles that were too large to be miscible in the glaze solution. Essentially, however, the glazing techniques used by the Bells and the Eberlys were the same, mainly due to the fact that members of the Fleet family worked in both organizations. Furthermore, as documented by letters, Samuel and John Bell constantly traded their glazing formulas and continually experimented with new materials and new methods of compounding and glazing.

Baecher was probably the most expert at glazing of all the Valley potters. Proper glazing demanded a good deal of attention and concern. The potter was compelled to control the temperature of the kiln closely; too much or too little heat could cause improper fusion. This was normally accomplished by carefully observing changes in the appearance of the

objects in the kiln during firing and carefully controlling the heat. Baecher, evidently a master at this control, although he applied his glazes in much thinner layers than other pottery decorators, seldom overheated his wares. While Baecher used similar glazing materials, his finished product appeared quite different from those of the other potters. The classic Baecher glaze was one that was marbleized and mocha-like (see Plate 57), capitalizing on the bleeding effect on a white slip ground. There was a greater tendency in Baecher's production toward a splotched effect similar to the Rockingham glaze.

John George Schweinfurt glazed his products very sparingly, a trait that probably resulted from depressed economic conditions in his area of the Valley. Schweinfurt occasionally used a slip type underglaze, with manganese or iron-oxide splatter design. He more often used a basic clear lead glaze as described above. This particular glaze contained more silica than those of other potters. Schweinfurt also used an iron-oxide glaze alone on many objects.

For all the potters under discussion, the glazing materials were normally bought from a local supplier, especially the cobalt and copper oxide. Manganese was either mined or purchased from suppliers, as was lead. Silica was normally mined locally in the form of flint or quartz.

A quern, or grinding mill, not unlike that used for the grinding of grain, was used to grind the glazing materials into powder form.

COBALT-DECORATED SALT-GLAZED STONEWARE

Salt-glazing on cobalt-decorated stoneware was the other common type of glazing used in the Shenandoah Valley.

After it had dried to a leather-hard state, the stoneware object was decorated with a cobalt-blue glaze, which was actually a slip rather than a true glaze. The kiln was fired at much higher temperatures than required for earthenware. At the appropriate moment, common salt was thrown into the kiln; the salt vaporized, and was deposited on every exposed surface within the kiln, forming an impermeable glaze with an orange-peel textured surface.

Various cobalt slip designs were used, including tulips, leaves, foliate vines, C-scrolls, a name or an initial, and even occasionally a verse. The Valley potters mimicked each other's cobalt designs to such an extent that many unmarked pieces are virtually impossible to attribute.

THE KILN

The kiln was normally of a rounded beehive shape, from seven to nine feet tall at the center and of varying width. Usually the outer surface was stone and the interior fire brick. It was heated by attached fireplaces and fueled by cord wood.

Samuel Bell's kiln was of rounded and double-arched design. It was seven feet, four inches in height and eight and one-half feet in diameter. It had four fire holes and two dozen flues.

Pottery objects were stacked in the kiln one on top of another, normally separated by small wads or chunks of clay to prevent "glueing," or sticking together. These pieces of clay were known as "plats" and "frows." Plats separated the pottery horizontally while the frows separated them vertically. They were sanded so that they could be separated more easily.

Firing normally required two or three days. After the master potter judged the firing to be complete, he would allow the kiln to cool, which often required another five or six days.

Many accidents occurred while the pottery was being fired. Often vessels would change shape, glaze would receive too much or too little heat, pieces would crack or be chipped. These factors sometimes have caused confusion in identifying or attributing pieces.

One never finds a Valley pottery object showing signs of having been fired on a trivet, nor were saggers used. Essentially the Valley potter did a remarkable job of production considering the amount of kiln furniture he worked with.

MARKETING

Marketing normally was not complicated. Usually the potter worked from specific orders. Often he would let it be known that a kiln was to be opened, and usually more than enough purchasers would show up. The majority of his wares would be "wagoned." The potter's horse-drawn or mule-drawn wagon would be loaded, and pottery would be packed in straw for the long haul over rocky and often muddy roads. Wagon trips could last more than a week, with customers even extending into Pennsylvania, Maryland, West Virginia, Kentucky, and Tennessee. The Great Wagon Road, later called Valley Pike and now known as U.S. Route 11, extended through Strasburg and Winchester and far to the north and south, certainly a geographic convenience that contributed toward successful marketing.

In the latter part of the nineteenth century, Valley potters had to face new problems. Competition between potteries was increasing; steam pottery production was rapidly becoming a factor; the constant proliferation of the railroads made delivery from distant places more rapid and economical; increased costs of raw materials and labor prevented adequate margins of profit; and the accelerated production of glass containers was certainly a deadly blow to the pottery business.

These, ultimately, were the factors that led to the demise of the once prolific Shenandoah Valley pottery industry. By 1908, they had all closed.

H. E. Comstock
Winchester, Virginia

SHENANDOAH POTTERY REGION

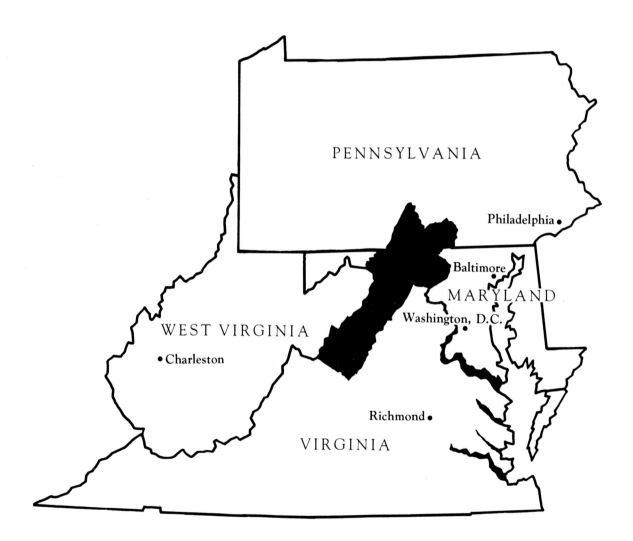

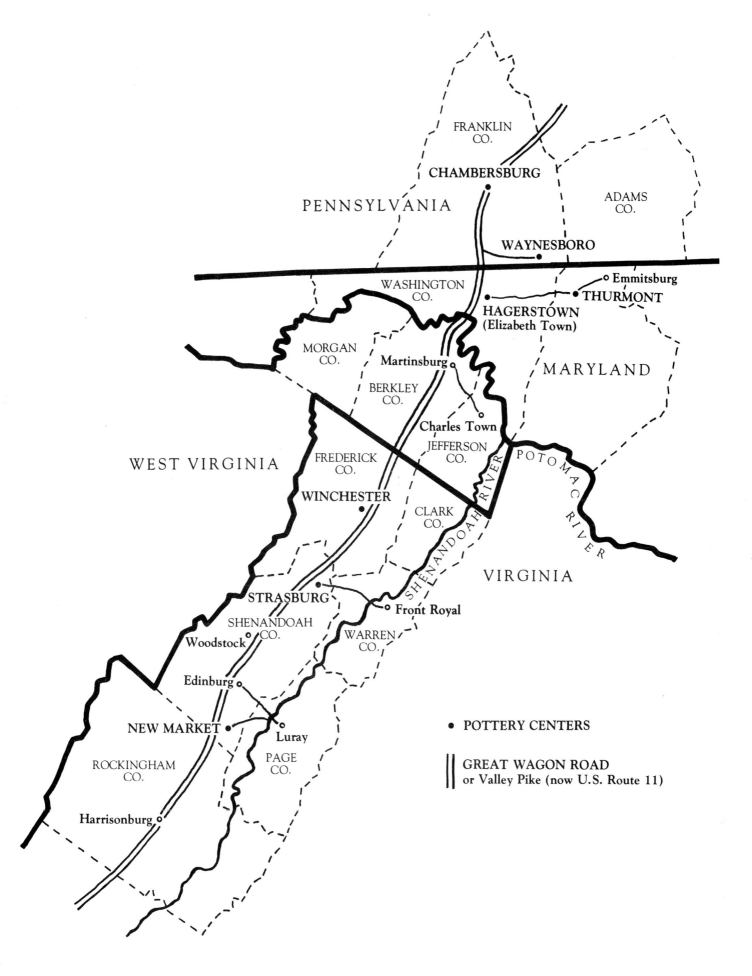

FRANKLIN
CO.

CHAMBERSBURG

PENNSYLVANIA

ADAMS
CO.

WAYNESBORO

WASHINGTON
CO.

Emmitsburg

THURMONT

HAGERSTOWN
(Elizabeth Town)

MORGAN
CO.

Martinsburg

MARYLAND

BERKLEY
CO.

Charles Town

WEST VIRGINIA

FREDERICK
CO.

JEFFERSON
CO.

POTOMAC RIVER

SHENANDOAH RIVER

WINCHESTER

CLARK
CO.

VIRGINIA

STRASBURG

Front Royal

SHENANDOAH
CO.

WARREN
CO.

Woodstock

Edinburg

NEW MARKET

Luray

● POTTERY CENTERS

PAGE
CO.

ROCKINGHAM
CO.

‖ GREAT WAGON ROAD
or Valley Pike (now U.S. Route 11)

Harrisonburg

I

PETER BELL
1775-1847

BOWL

Peter Bell, Winchester, Virginia,* early 19th century**
Mark: stamped, *P BELL*
Redware; height 5½ inches, diameter 22½ inches (13.97 by 57.15 cm.)
Courtesy Museum of Early Southern Decorative Arts,
 Winston-Salem, North Carolina

Peter Bell was the patriarch of the Bell family potters, and this large bowl is one of the earliest known marked pieces of Bell pottery. The design, shape, and inclusion of grip handles on the underside are repeated in later pieces. The decoration and craftsmanship of this bowl indicate a level of advancement not evident in other late nineteenth-century Bell wares.

*Indicates location of pottery.

**Early nineteenth century, 1800-1832
 Mid nineteenth century, 1833-1869
 Late nineteenth century, 1870-1908

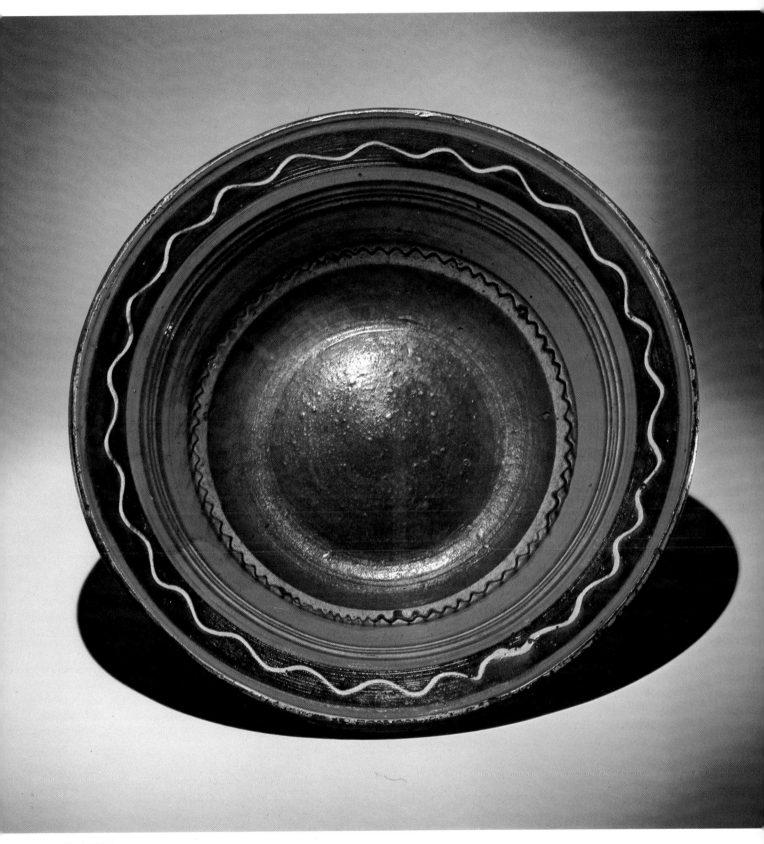

PLATE 1

II

JOHN BELL
1800-1880

FIGURE of a LION

John Bell, Waynesboro, Pennsylvania, mid 19th century
Redware; height 7½ inches, length 8½ inches (19.05 by 21.59 cm.)
Private Collection

The originality of design, well proportioned body, and toothy grin make this lion a unique piece of American folk sculpture. John Bell made it for a niece in Winchester, Virginia.* The tail and mane were fashioned by forcing clay through coarse burlap, resulting in an effect called "coleslaw."

To date, three John Bell lions are known, and they are virtually identical. A second lion is in the collection of the Henry Ford Museum, and a third, which is stamped with the artist's name, is in the Henry Francis du Pont Winterthur Museum. A lion by Solomon Bell belongs to the Museum of Early Southern Decorative Arts and is illustrated in Plate 9.

*An early collector, W. Dan Quattelbaum, purchased this lion in 1923 directly from one of John Bell's nieces, a Miss Crum of Winchester. She stated that John Bell made the lion for her. She also recalled, as a child, dropping a slate pencil in the lion's ear; it remains there today.

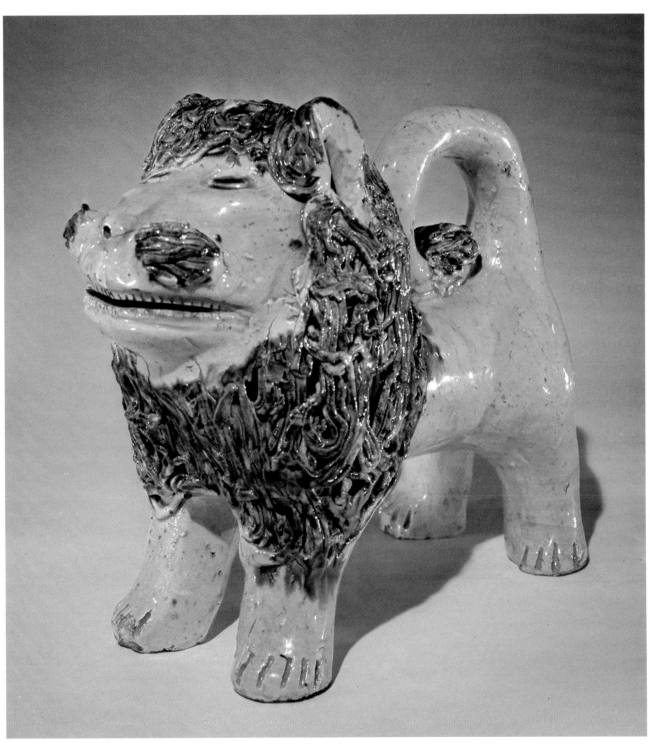

PLATE 2

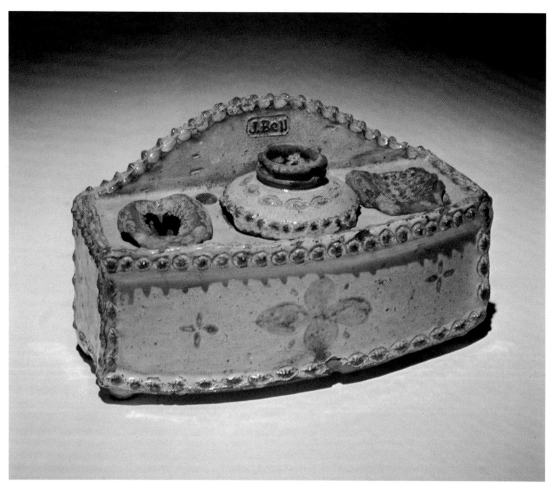

PLATE 3

INKWELL

John Bell, Winchester, Virginia, 1825
Marks: stamped in raised letters, *J. Bell;* incised on back in script,
 Winchester, March 12th, 1825
Redware; height 3 inches, length 5 inches (7.62 by 12.70 cm.)
Private Collection

This prominently marked John Bell inkwell, a very early work, was executed at the pottery of Peter Bell in Winchester, Virginia. It is thought to be the only surviving piece made by John Bell before he moved to Pennsylvania. The oval embellishment gives a clue to identifying later pieces with this same decorative motif. The brushed decoration on a blueish-white ground is reminiscent of English delftware.

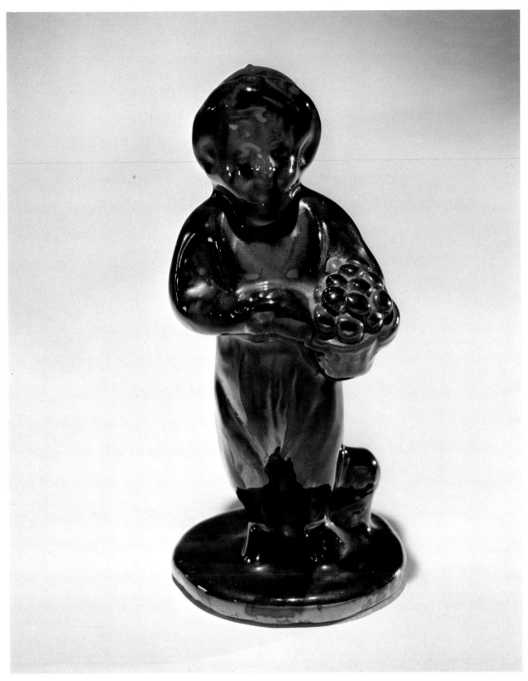

PLATE 4

FIGURE of BOY with BASKET of FRUIT

Attributed to John Bell, Waynesboro, Pennsylvania, mid 19th century
Redware; height 6 inches (15.24 cm.)
Private Collection

The somber look of the boy is accentuated by the light and dark brown
glaze, an effect especially noticeable in the pattern around the eyes. The
upper torso and head of this molded figure appear to have been used as the
model for the finial on top of Richard Franklin (Polk) Bell's water cooler
in Plate 35.

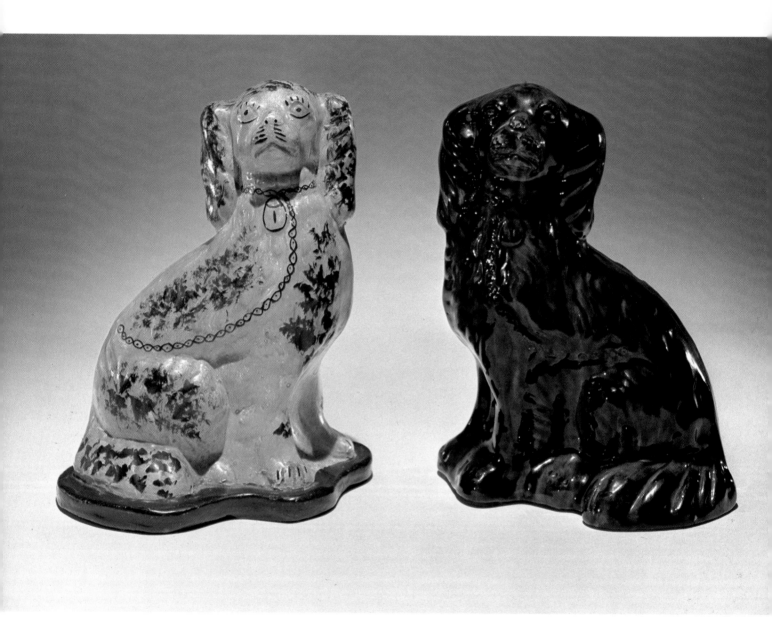

PLATE 5

FIGURES of SPANIELS

Left: John Bell, Waynesboro, Pennsylvania, mid 19th century
Mark: stamped, *JOHN BELL*
Redware; height 9 inches (22.86 cm.)
Private Collection

Right: John Bell, Waynesboro, Pennsylvania, late 19th century
Mark: stamped, *JOHN BELL / WAYNESBORO*
Redware; height 9 inches (22.86 cm.)
Private Collection

These molded figures strongly resemble English Staffordshire dogs. A sponged, painted* decoration embellishes the white ground of the spaniel on the left, which sits stiffly on a raised base. The other figure, although similarly molded, appears less rigid because of the flowing glaze.

*When the term "painted" appears, it refers to the use of oil-base paint, rather than glaze.

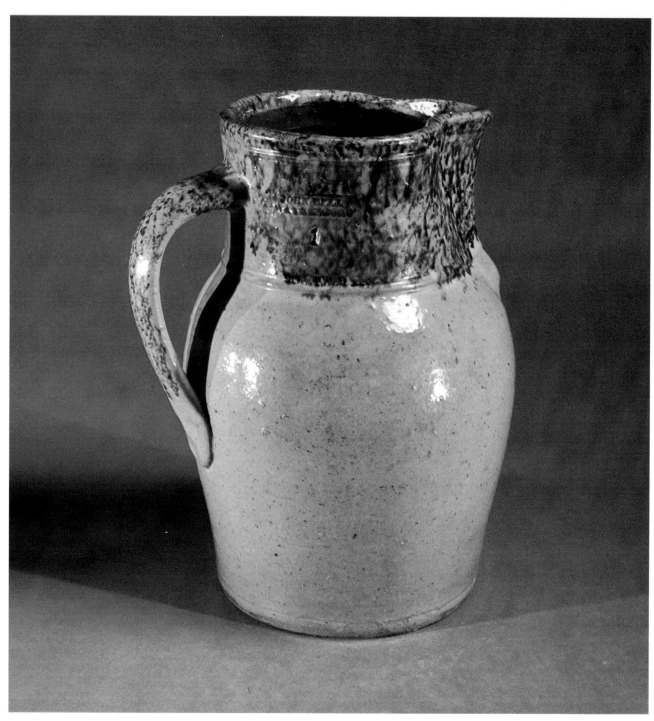

PLATE 6

PITCHER

John Bell, Waynesboro, Pennsylvania, mid 19th century
Mark: stamped, *JOHN BELL / WAYNESBORO*
Redware; height 10 inches (25.40 cm.)
Private Collection

This handsome pitcher has an even, high-gloss glaze overall and a delicate brown wash on the neck and handle. Banding is used around the neck and rim, and the deep spout continues into the body. The pitcher is celadon, a color not often seen in Bell pottery.

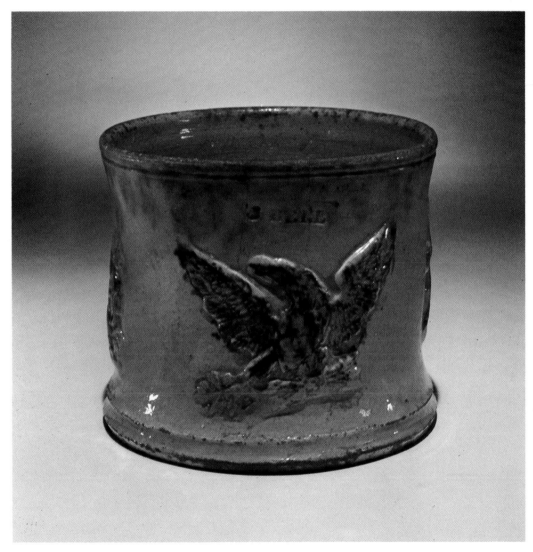

PLATE 7

MUG

John Bell, Waynesboro, Pennsylvania, mid 19th century
Mark: stamped, *J. BELL*
Redware; height 3⅝ inches (9.21 cm.)
Courtesy Henry Ford Museum, Dearborn, Michigan

This mug demonstrates the use of American patriotic designs on utilitarian wares. The spread-winged eagle was a popular decorative motif of the nineteenth century.

III

SAMUEL BELL
1811-?

SOLOMON BELL
1817-1882

RICHARD FRANKLIN (POLK) BELL
1845-1908

CHARLES FORREST BELL
1864-1933

FIGURE of a WHIPPET

Solomon Bell, Winchester, Virginia, early 19th century
Mark: incised in script, *Solomon Bell / Winchester*
Redware; height 6½ inches, length 10 inches (16.51 by 25.40 cm.)
Private Collection

This molded whippet with crossed forepaws displays the refinement and diversity of which the Bell family potters were capable. Whippets appear to have been a favorite item with the Bells and their customers. Solomon Bell crafted this piece before moving to Strasburg, Virginia, while still at the Peter Bell pottery in Winchester.

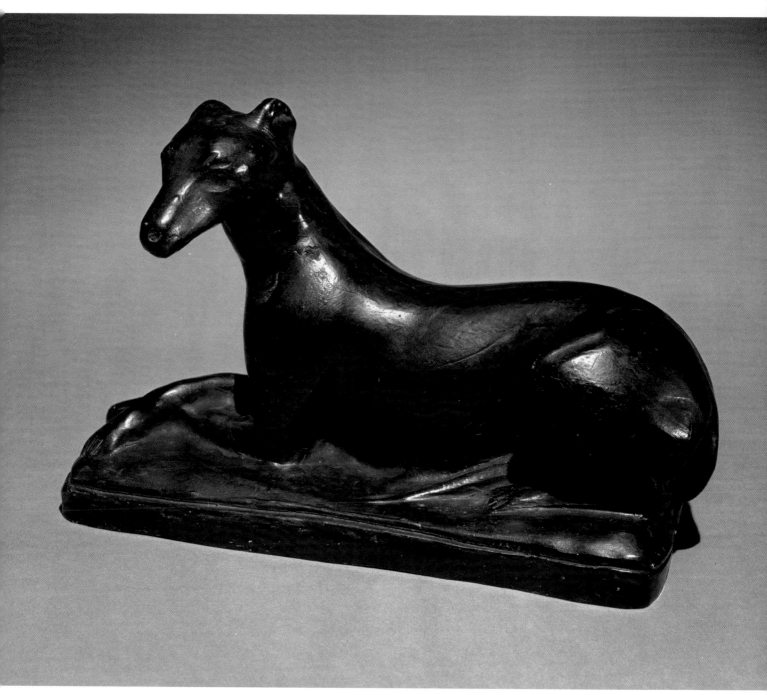

PLATE 8

FIGURE *of a* LION

Solomon Bell, Strasburg, Virginia, mid 19th century
Redware; height 11 inches, length 13½ inches (27.94 by 34.29 cm.)
Courtesy Museum of Early Southern Decorative Arts,
 Winston-Salem, North Carolina

This lion, which is thought to have been used as a doorstop, is heavier and
has larger proportions than the John Bell lion in Plate 2. It was made for
Solomon Bell's niece and was purchased from her relatives. Each of the
four known lions was made for a member of the Bell family.

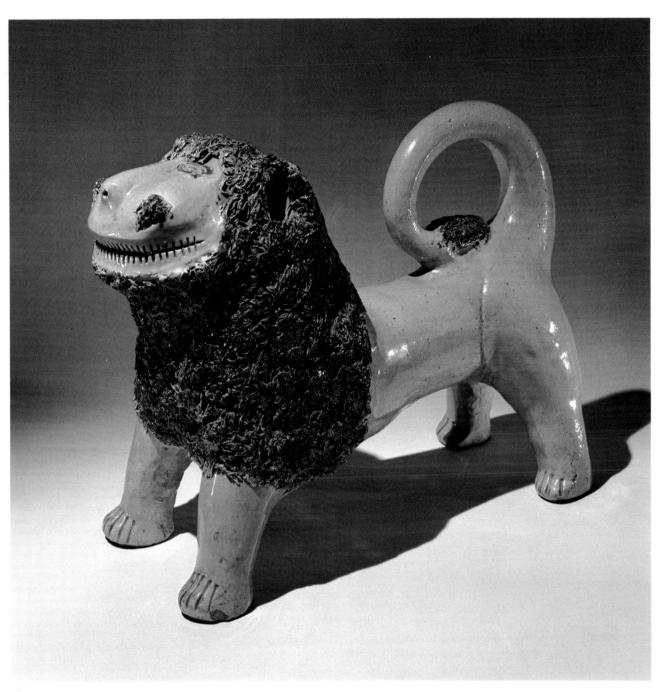

PLATE 9

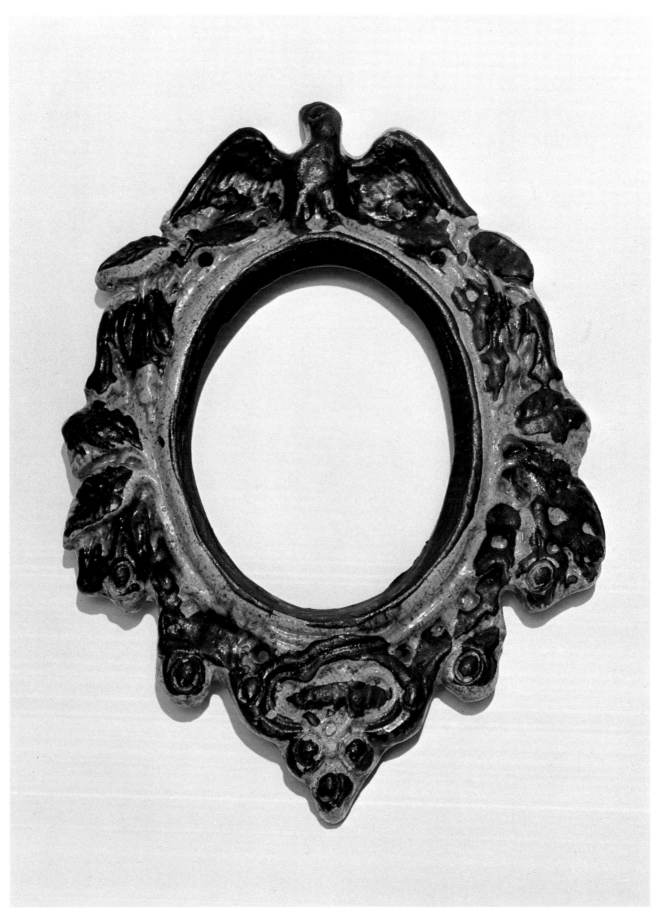

PLATE 10

PICTURE FRAME

Samuel Bell, Strasburg, Virginia, mid 19th century
Mark: molded in raised letters, *S. BELL*
Redware; height 11¼ inches (28.58 cm.)
Courtesy Michael H. Supinger, Linden, Virginia

An eagle surmounts this unusual earthenware picture frame. Molded with fruit and leaves in relief, the frame has a ground of cream glaze with accents of brown and green. It was hung by ribbon or wire threaded through holes near the top. These picture frames were sold commercially and were also used by the Bell family for portraits.

DOUBLE BOTTLE

Solomon Bell, Strasburg, Virginia, mid 19th century
Mark: stamped, *SOLOMON BELL / STRASBURG / Va.*
Redware; height 8 inches (20.32 cm.)
Private Collection

This rare double bottle is one of two known from the Shenandoah Valley. The fact that it is a molded piece indicates that many of them were made; it is therefore curious that so few have survived. The men are dressed in waistcoats, vests, and bow ties, and each holds a mug in his right hand. The hats, which served as stoppers, have been lost. In a similar double bottle in the Henry Francis du Pont Winterthur Museum, the men stand back to back rather than adjacent to one another. This double bottle might have been used for oil and vinegar.

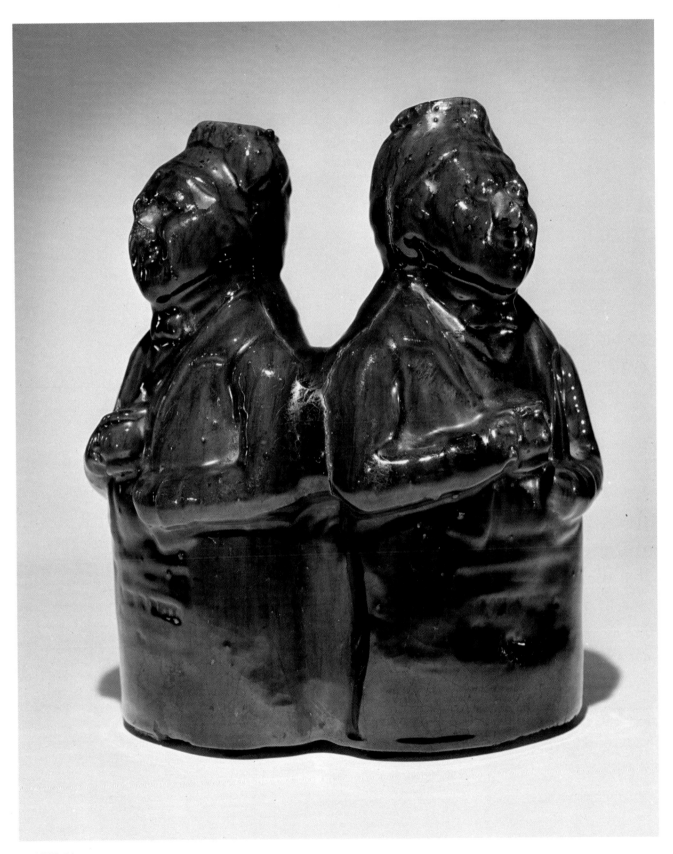

PLATE 11

41

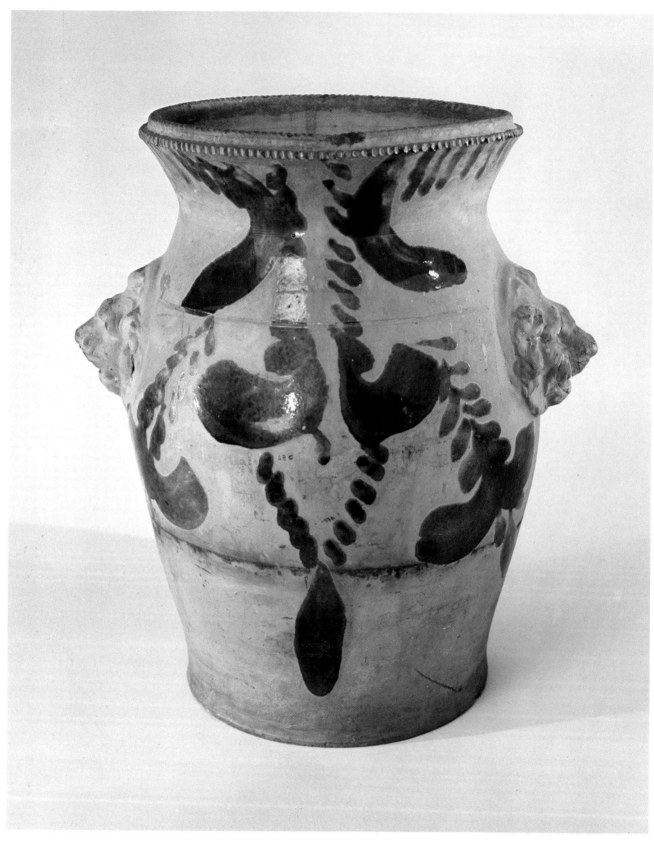

PLATE 12

FLOWER VASE *with* LION-HEAD HANDLES

Attributed to Solomon Bell, Strasburg, Virginia, mid 19th century
Redware; height 15¼ inches (38.74 cm.)
Courtesy Mrs. Mary Cramer, Bridgewater, Virginia

This vase is glazed in white slip; the decorative elements are glazed in a high-gloss green. Contributing to the beauty of the piece are the lion-head bosses, which serve as handles, and the delicately scored rim. The vase was partially buried for years, leaving a ring and noticeable discoloration on the area that was below the ground.

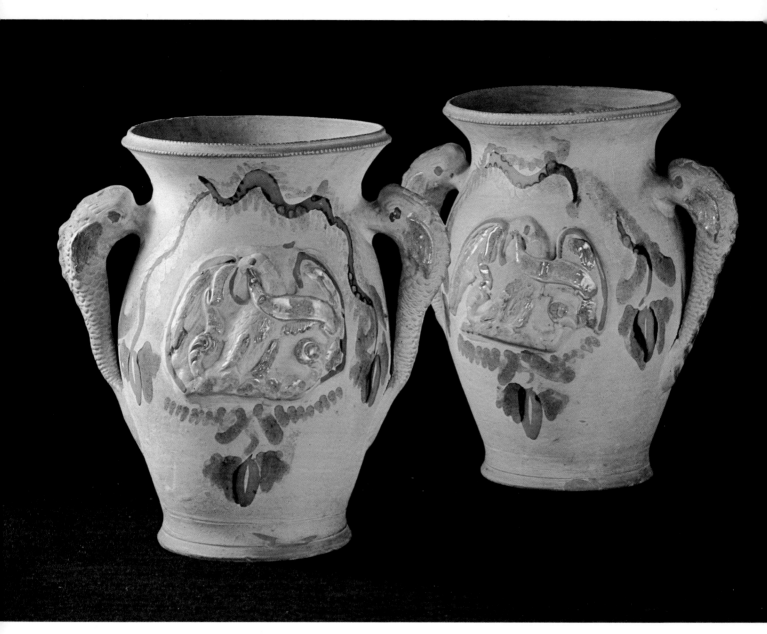

PLATE 13

PAIR of VASES with DOLPHIN HANDLES

Solomon Bell, Strasburg, Virginia, mid 19th century
Mark: stamped, *SOLOMON BELL / STRASBURG*
Redware; height 16 inches (40.64 cm.)
Courtesy Henry Francis du Pont Winterthur Museum, Winterthur, Delaware

Features of these vases are dolphin handles and spread-winged eagles in relief.
The decorations surrounding the eagles are in a high-gloss glaze, in contrast to
the white ground coating. The rims are scored in a delicate pattern.

FIGURE of a DOG

Solomon Bell, Strasburg, Virginia, mid 19th century
Mark: stamped, *SOLOMON BELL / STRASBURG, Va.;* incised under
 glaze in script, *Solomon / Bell*
Redware; height 8½ inches (21.59 cm.)
Private Collection

Fine glazing distinguishes this molded dog by Solomon Bell. The separated
foreleg is unusual in Shenandoah spaniels. Dogs of different varieties were
popular sculptural subjects in the middle and late nineteenth century.

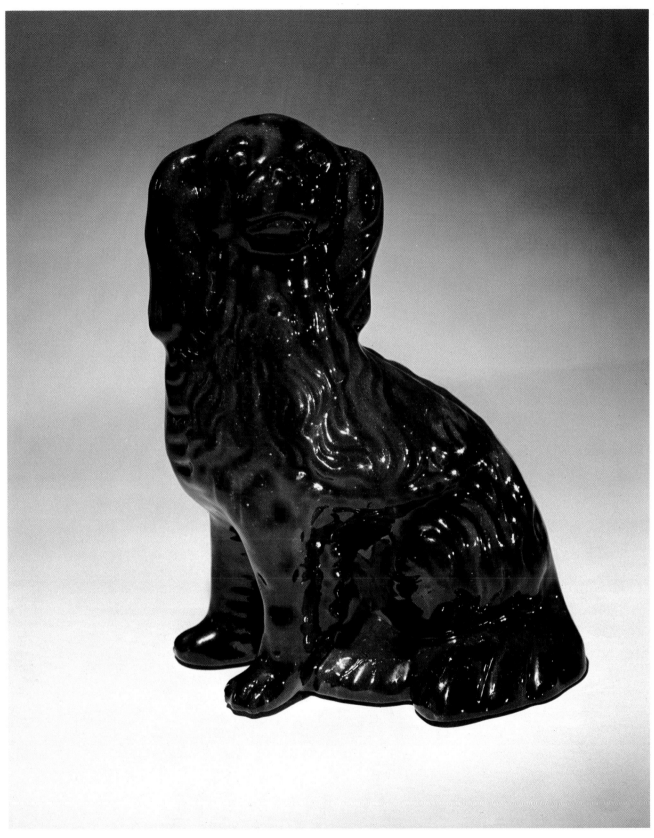

PLATE 14

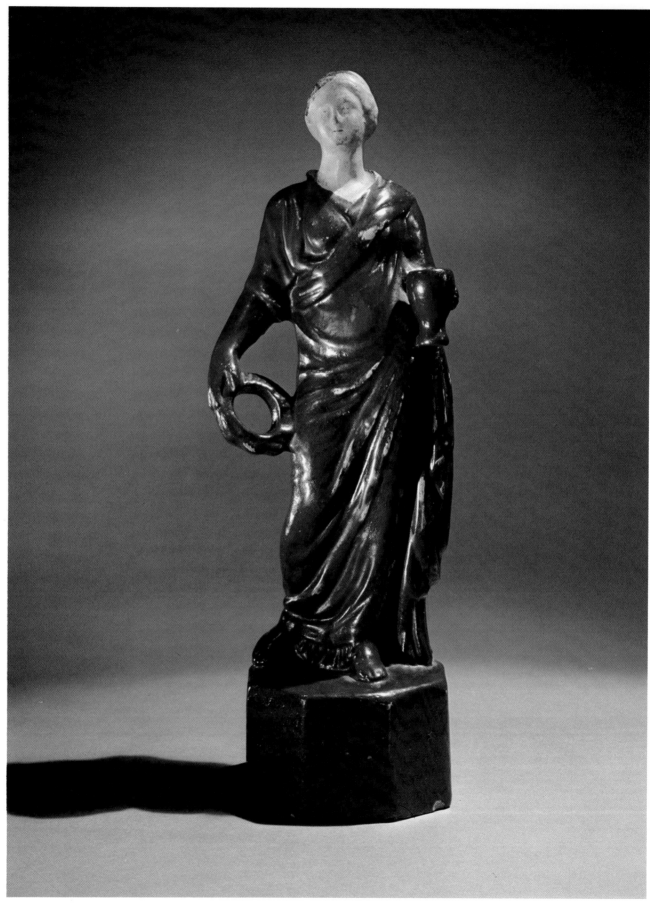

PLATE 15

48

FIGURE of a WOMAN

Solomon Bell, Strasburg, Virginia, 1862
Mark: incised in script, *Solomon Bell / Strasburg Va 1862*
Redware; height 16⅛ inches (40.96 cm.)
Courtesy Henry Ford Museum, Dearborn, Michigan

This neo-classical style figure is a molded piece. The woman's robe is painted brown and her neck and head are in white slip. The facial features were originally accentuated with color.

WATER COOLER

Solomon Bell, Strasburg, Virginia, mid 19th century
Mark: stamped, *SOLOMON BELL / STRASBURG, Va.*
Stoneware; height 23 inches (58.42 cm.)
Courtesy Philadelphia Museum of Art, Purchased The Annual
 Membership Fund

This salt-glaze water cooler exhibits incised, stamped, applied, and cobalt decorations. The cobalt-blue tulips are highly stylized and are freer in execution than the small raised and incised decoration that forms a yoke pattern around the spout. The ring handles, bristling with applied buttons, encircle a man's face and are in turn girded by small rings. For height and convenience, a stoneware stand was provided.

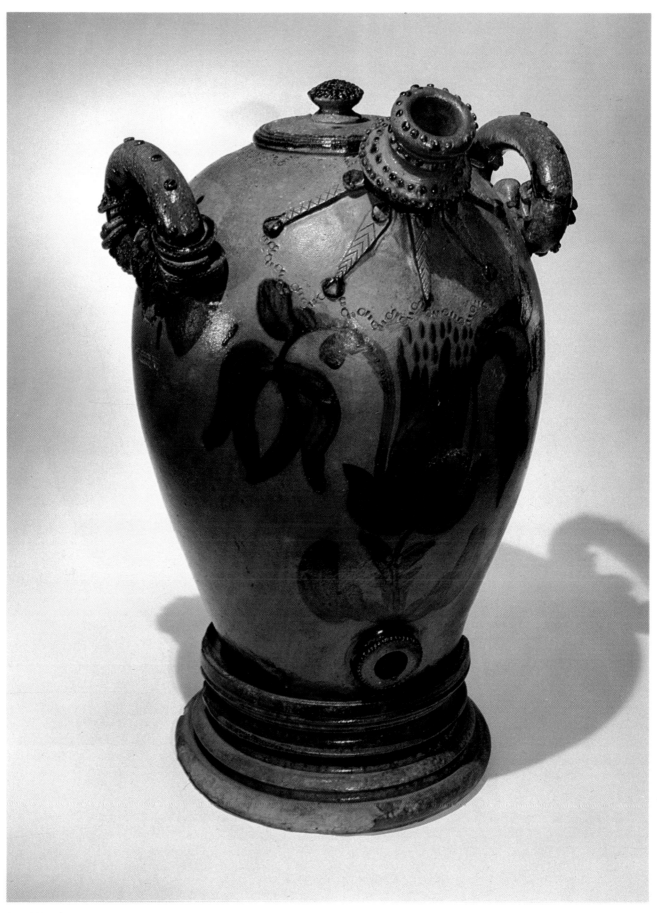

PLATE 16

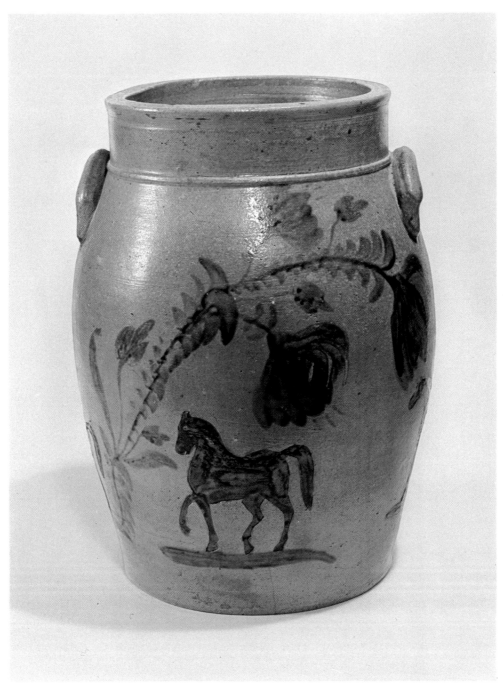

PLATE 17

JAR

Samuel Bell, Strasburg, Virginia, mid 19th century
Mark: stamped, *S. BELL*
Stoneware; height 16 inches (40.64 cm.)
Private Collection

The majority of Valley stoneware was devoid of elaborate cobalt decoration. Most examples have simple floral ornamentation, but the use of horses is unique. This jar features four horses, two of them prancing and two standing. The figures were created by lightly impressing templates, perhaps cut sheet-tin, into the clay while it was still wet or in the leather-hard state. The resultant recessed areas were then filled with cobalt blue.

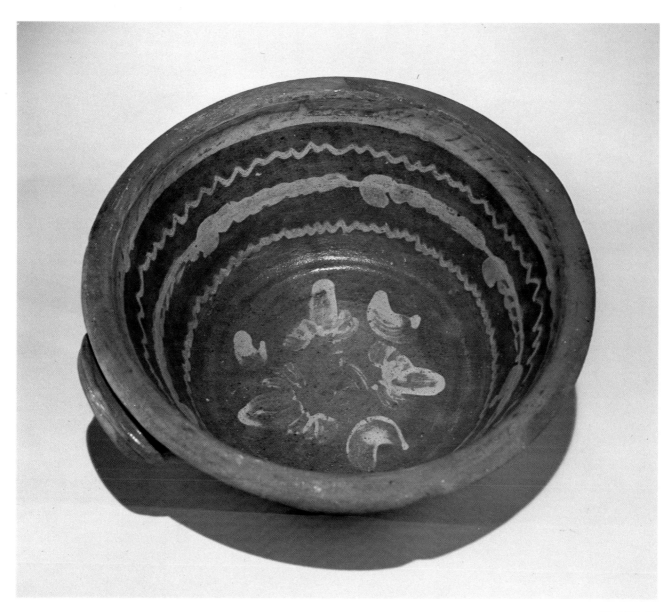

PLATE 18

BOWL

S. Bell & Son, Strasburg, Virginia, late 19th century
Mark: stamped, *S. BELL & SON / STRASBURG*
Redware; height 6 inches, diameter 13 inches (15.24 by 33.02 cm.)
Private Collection

Although the slip decoration is bold, it is less skillfully applied to this bowl
than to those in Plates 1 and 19. Note the grip handles, which appear on
all signed slipware bowls from the Bell family.

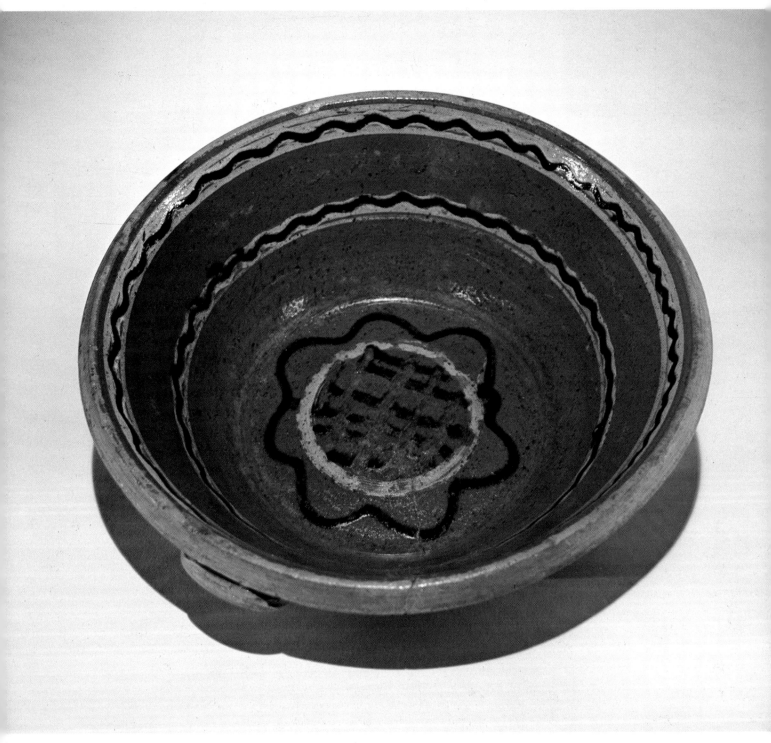

PLATE 19

BOWL

Solomon Bell, Strasburg, Virginia, mid 19th century
Mark: *SOLOMON BELL / STRASBURG*
Redware; height 5 inches, diameter 15 inches (12.70 by 38.10 cm.)
Courtesy Dr. James V. Kiser

Trailed slip decoration is used extensively in this striking piece. The design is in complete harmony with the proportions of the bowl. A stylized, cross-hatched medallion decorates the center, a pattern that is repeated in other Shenandoah pottery.

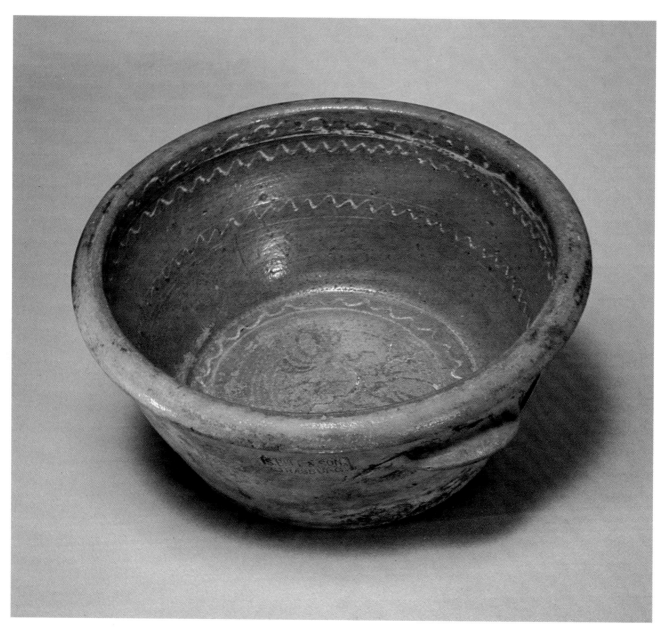

PLATE 20

BOWL

S. Bell & Son, Strasburg, Virginia, late 19th century
Mark: stamped, *S. BELL & SON / STRASBURG*
Redware; height 6 inches, diameter 15 inches (15.24 by 38.10 cm.)
Private Collection

The inside of this bowl is decorated with a white slip design found on numerous other utilitarian products of the Bell pottery (see Plate 21). Since the bowl is stamped with the maker's mark, it provides a key to identifying other pieces with similar markings.

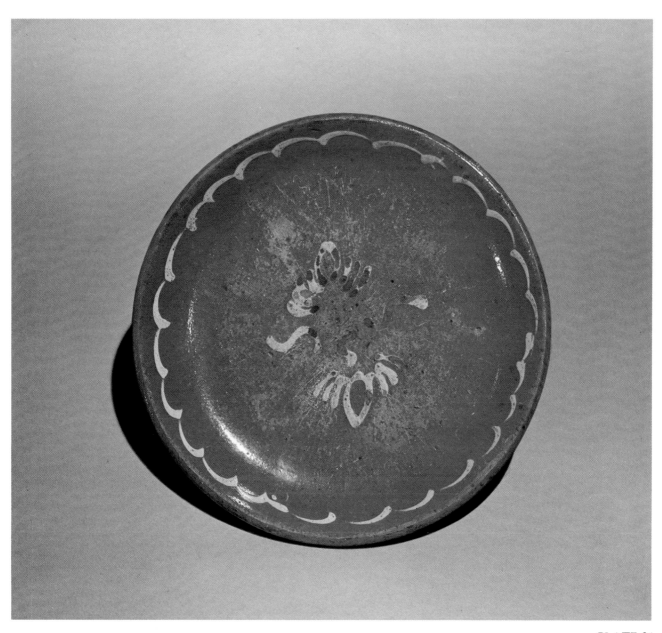

PLATE 21

PLATE

Attributed to S. Bell & Son, Strasburg, Virginia, late 19th century
Redware; diameter 9 inches (22.86 cm.)
Courtesy Mr. and Mrs. Roddy Moore

One of a set of four molded plates, this piece is important due to the center
slip design (see Plate 20), seen occasionally on other S. Bell & Son
pottery. Both this plate and the bowl in Plate 20 are examples of the Bell
daily wares that were wagoned throughout the Valley.

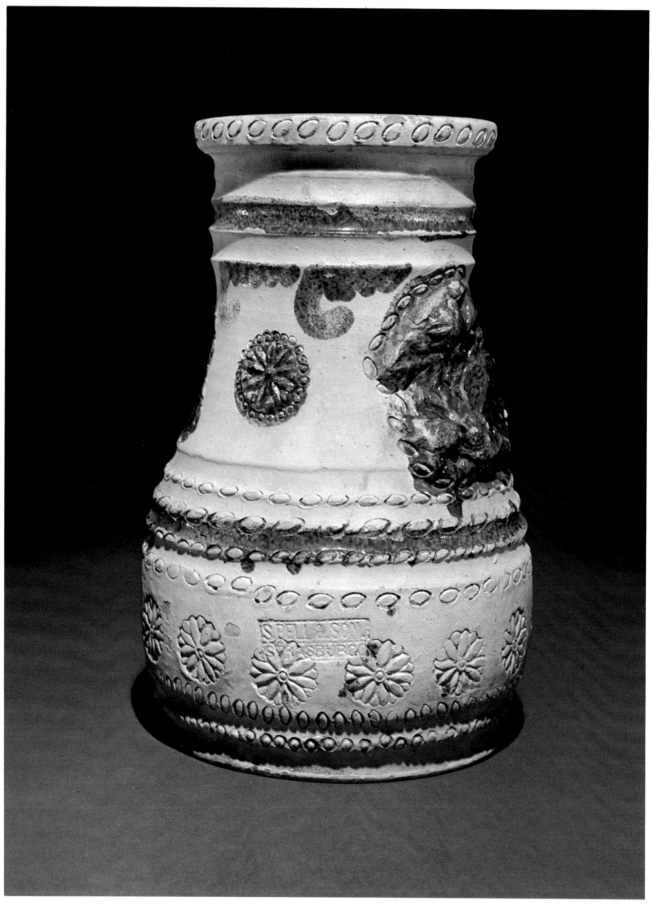

PLATE 22

58

VASE

S. Bell & Son, Strasburg, Virginia, late 19th century
Mark: stamped, *S. BELL & SON / STRASBURG;* incised in script,
 S. Bell & Sons
Redware; height 13¼ inches (33.66 cm.)
Courtesy Henry Ford Museum, Dearborn, Michigan

The circle and oval as decoration was used as early as 1825 by John Bell
(see Plate 3). The combination of ovals and circles, or just the use of ovals,
is seen on many marked as well as attributed pieces of Bell pottery for the
duration of the nineteenth century. This motif, along with the design,
type of clay, and often the provenance, has been used to document pieces
that most collectors and students had thought were purely Pennsylvania in
origin. Future attributions will be based on this example.

FIGURE of a SEATED DOG

Attributed to Samuel Bell, Strasburg, Virginia, mid 19th century
Redware; height 6 inches, length 7¼ inches (15.24 by 18.42 cm.)
Private Collection

An important feature of this figure is the stamped oval pattern bordering
the base. This pattern is first illustrated in Plate 22 and is repeated in Plates
24, 25, and 26. The glaze has been used effectively on the textured body
and the smooth forepaws. Similar modeling of eyes and eyebrows is seen on
the cat in Plate 25 and the minstrel man in Plate 26. The basket handle
originally in the dog's mouth is missing.

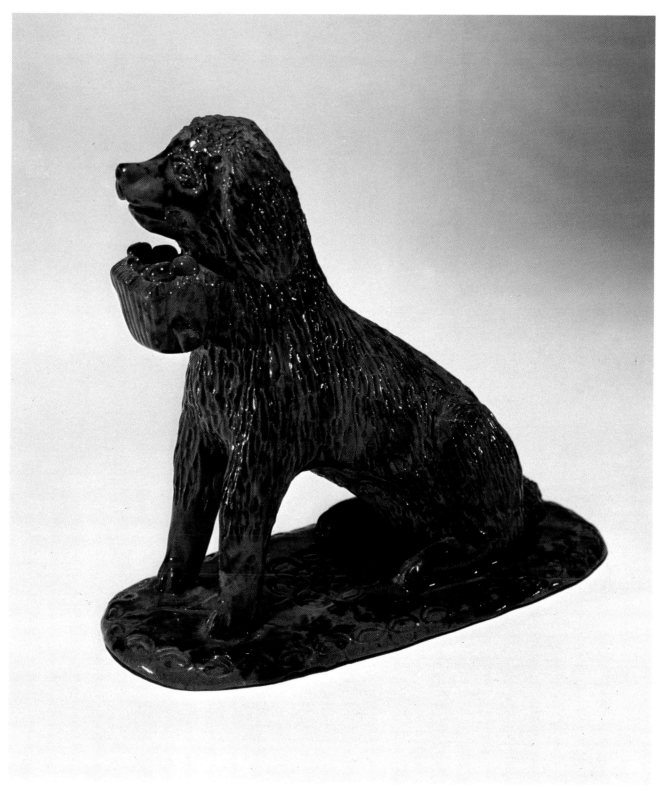

PLATE 23

PAIR *of* DOGS WITH RIDERS

Charles Forrest Bell, Strasburg, Virginia, late 19th century
Redware; height 10¾ inches (27.31 cm.)
Courtesy Henry Ford Museum, Dearborn, Michigan

These dogs with riders have a white slip ground and details accentuated with black paint. Charles Forrest Bell, a junior member in S. Bell & Son, was awarded first prize for this pair at the Woodstock, Virginia County Fair. The oval pattern shown in Plate 22 is repeated on the base of the right-hand figure; however, it is not easily seen because of the thick white slip that was applied after the decoration was completed.

An early collector, A. H. Rice, purchased these dogs from Charles Forrest Bell; thus it is safe to assume they were by his hand. This reinforces the theory that the oval-and-circle design is characteristic of Bell pottery.

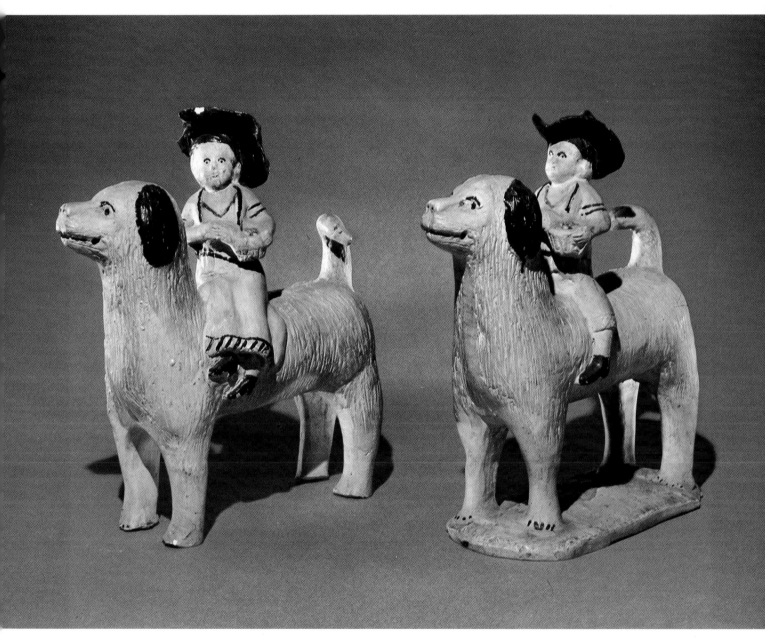

PLATE 24

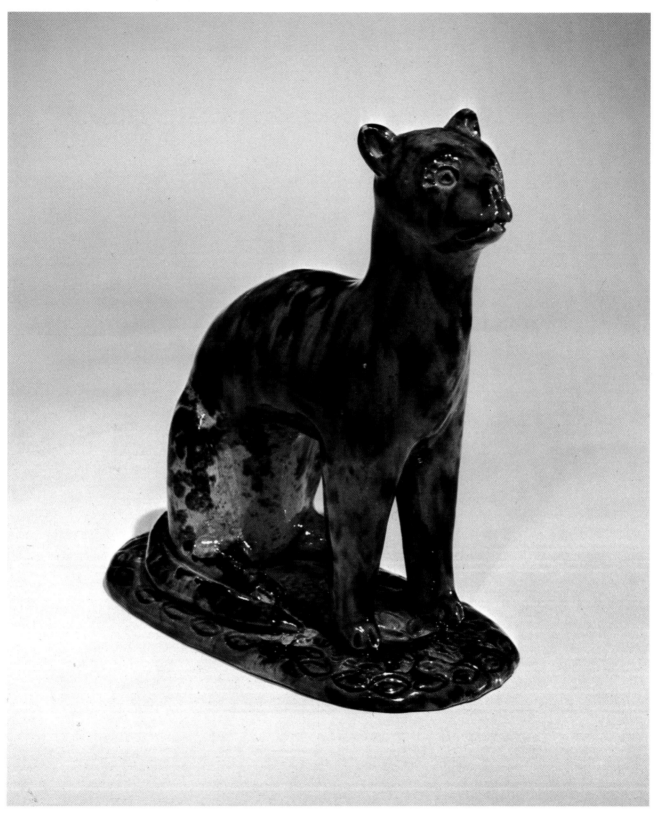

PLATE 25

FIGURE of a CAT

Attributed to Samuel Bell, Strasburg, Virginia, mid 19th century
Redware; height 6¼ inches (15.88 cm.)
Courtesy Mr. and Mrs. Boyd Headley, "Long Green," Winchester, Virginia

This cat, attributed to Samuel Bell, shows treatment of detail similar to the seated dog in Plate 23. Both pieces have the oval pattern seen in Plate 22. The eyes of the cat and dog are stylistically similar to those of the minstrel man in Plate 26.

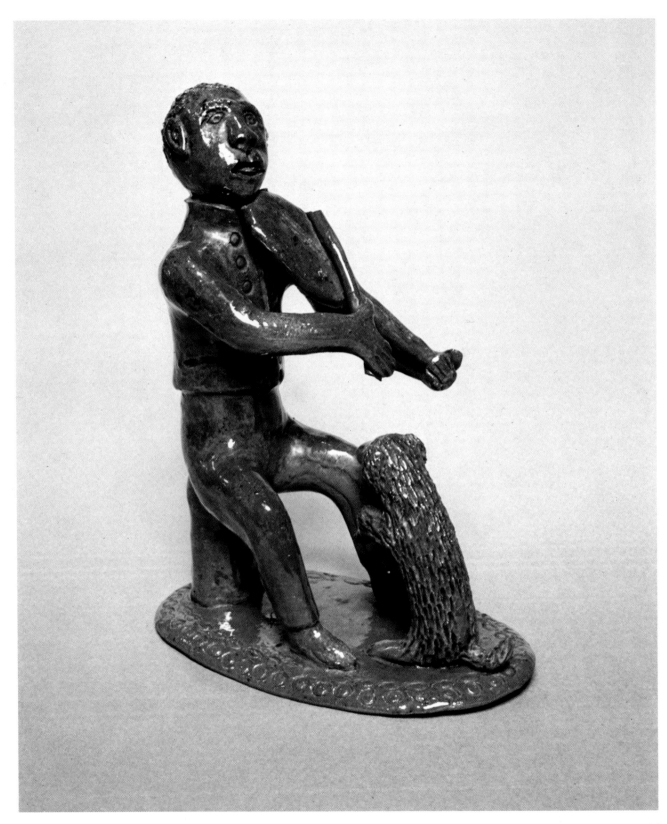

PLATE 26

FIGURE of a SEATED MINSTREL with DOG

Attributed to Samuel Bell, Strasburg, Virginia, mid 19th century
Redware; height 6½ inches (16.51 cm.)
Private Collection

A rare sculptural piece, this unique group is attributed to Samuel Bell. The fiddler and dog are skillfully incised and glazed in a rich olive tone; the variance in color is due to kiln conditions. The tooling of the dog's body is very similar to that of the seated dog in Plate 23, and the treatment of the eyes is reminiscent of the figures in Plates 23 and 25. The oval-and-circle pattern on the base, once again, is unmistakably similar to that seen earlier and adds strong evidence that this sculptural group should be attributed to Samuel Bell. (See base decoration of ovals and circles in Plate 22.) Another minstrel man with dog, similar in theme but quite different in execution, is in the collection of the New-York Historical Society in New York City.

FIGURE of a LAMB

S. Bell & Son, Strasburg, Virginia, late 19th century
Redware; height 3½ inches, length 12 inches (8.89 by 30.48 cm.)
Private Collection

Signs of wear indicate that this sculptural figure received considerable use and might have served as a doorstop. The mottled glaze (cream, green, and brown), which first came into use in the middle of the nineteenth century, enhances the textural effect of the lamb's fleece. It is thought that these sleeping lambs were also used as markers for children's graves. The lambs were often not glazed or were covered only with white slip, particularly when used as grave markers.

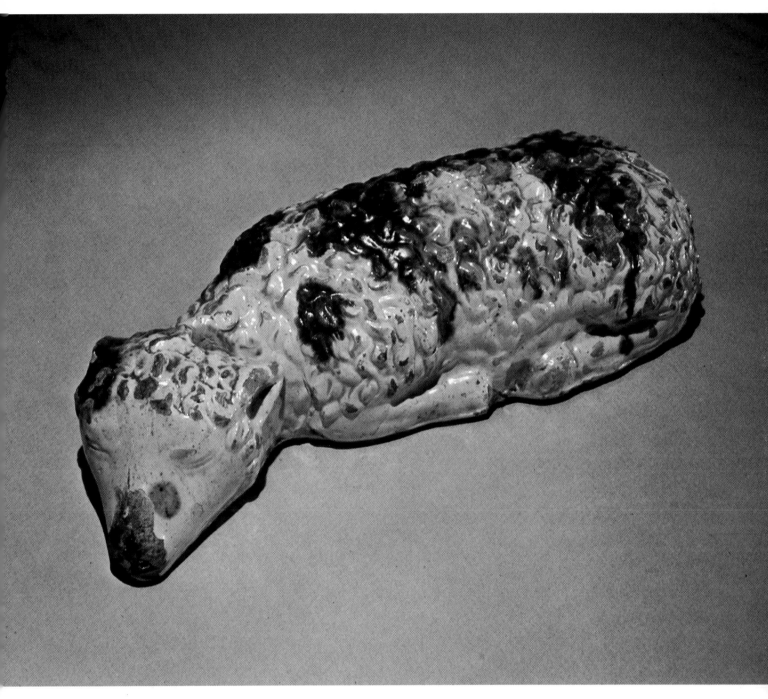

PLATE 27

CIDER JUG

S. Bell & Son, Strasburg, Virginia, late 19th century
Redware; height 7½ inches (19.05 cm.)
Private Collection

Modern in concept and decoration, this insulated jug was made with an inner hot water compartment to keep liquid in the outer compartment warm. The dark brown and green glaze covers large concentrated areas. The jug is extremely fine for a late nineteenth-century Bell piece. The craftsman who made it possessed considerable ingenuity, as well as skill.

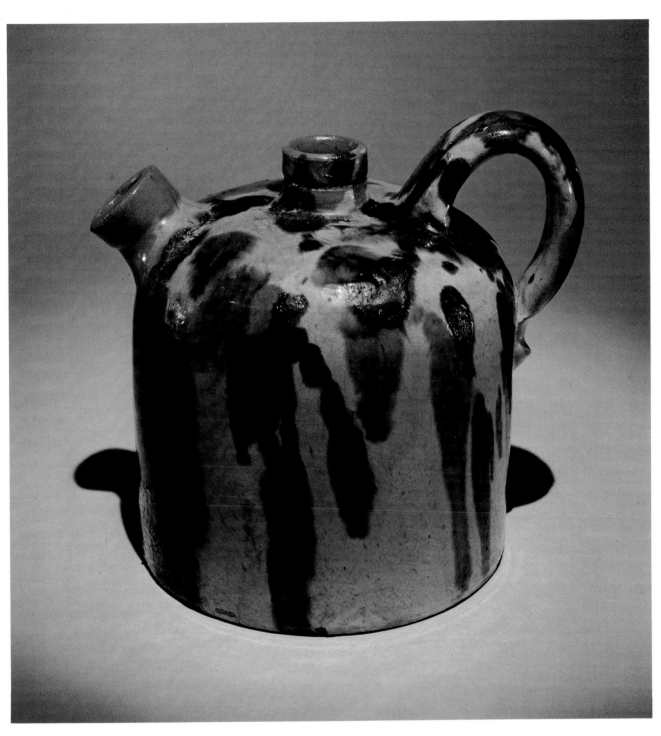

PLATE 28

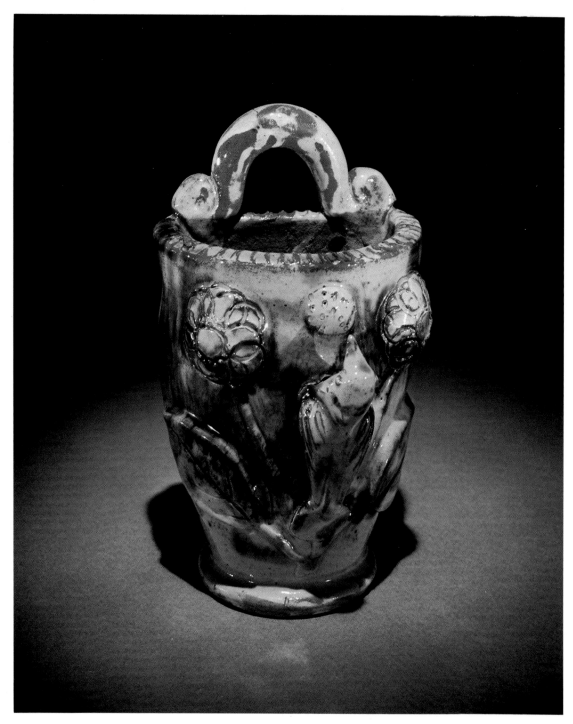

PLATE 29

WALL FLOWER HOLDER

S. Bell & Son, Strasburg, Virginia, late 19th century
Redware; height 7 inches (17.78 cm.)
Private Collection

A single bird in high relief with flowers and leaves in low relief appear on many pieces of Shenandoah pottery. They are used here to decorate a hanging flower holder, or wall pocket. The scroll handle serves functionally as well as decoratively, and a flat base allows the piece to be used in a standing position.

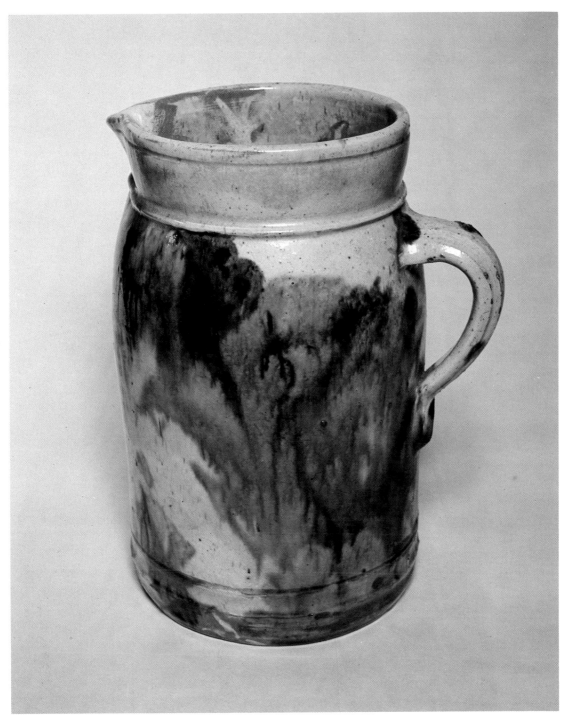

PLATE 30

WATER PITCHER

S. Bell & Son, Strasburg, Virginia, late 19th century
Redware; height 10⅝ inches (26.99 cm.)
Private Collection

This is a well proportioned pitcher with fine drip glaze. Available in many
sizes, these pitchers were produced in large numbers. Along with flower
pots, pitchers seem to have been the main output of the Bell pottery.

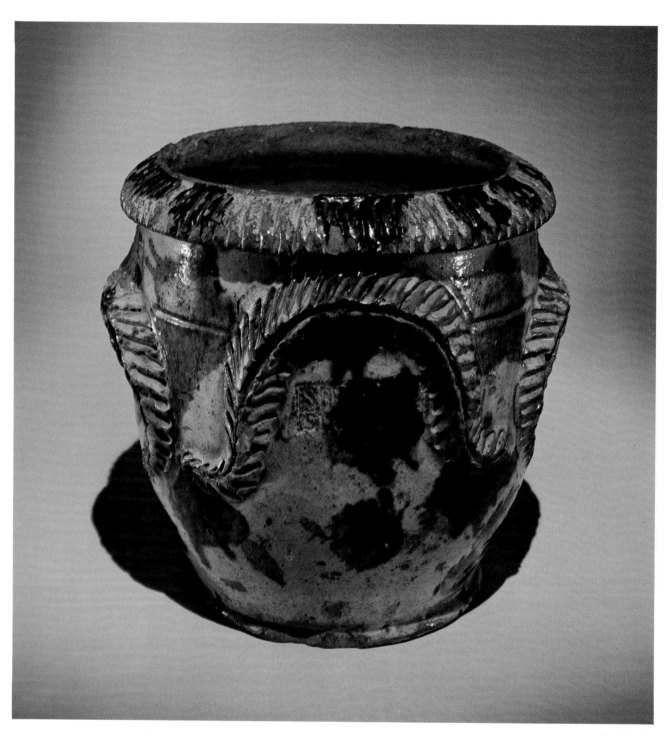

PLATE 31

FLOWER POT

S. Bell & Son, Strasburg, Virginia, late 19th century
Mark: stamped, *S. BELL & SON / STRASBURG*
Redware; height 8¼ inches (20.96 cm.)
Private Collection

The heavily incised, applied foliate decoration on this pot is very stylized
when compared with other pieces of Valley ware. The rim is heavily
scored, repeating the foliate design on the body.

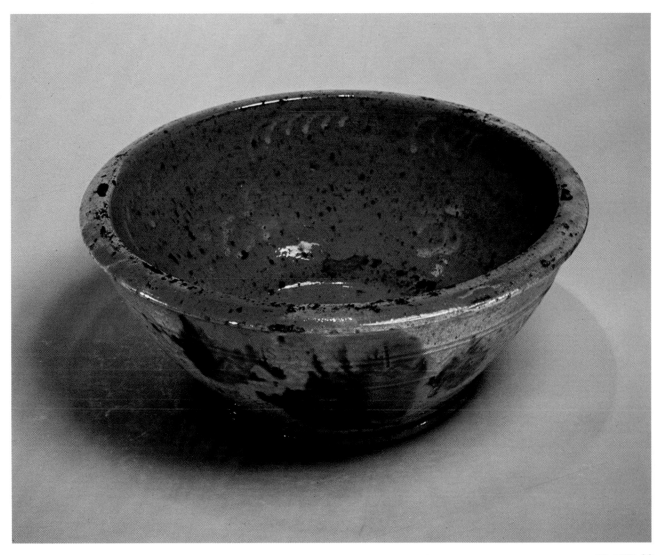

PLATE 32

BOWL

S.Bell & Son, Strasburg, Virginia, late 19th century
Mark: stamped, *S. BELL & SON / STRASBURG*
Redware; height 4¼ inches, diameter 10 inches (10.80 by 25.40 cm.)
Private Collection

Many interesting features appear on this bowl. The combination of slip
decoration, incising, and mottled glazing is not often seen in Bell pottery.
Here the stamp of S. Bell & Son is easily seen in the foreground.

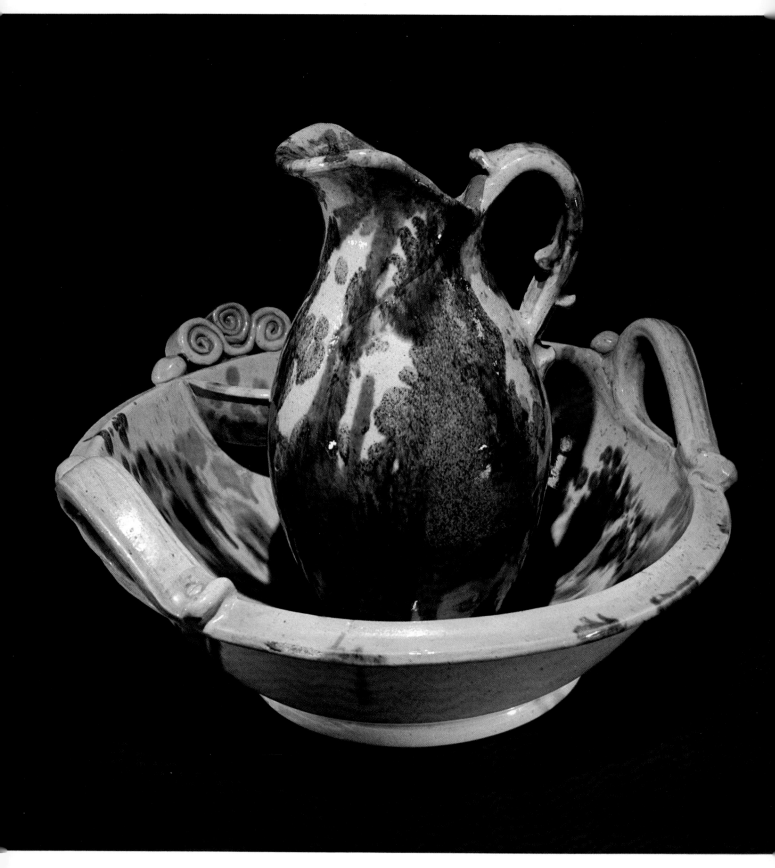

PLATE 33

WASH BOWL and PITCHER

S. Bell & Son, Strasburg, Virginia, late 19th century
Redware; height 12¾ inches (32.39 cm.)
Private Collection

Handles, a soap dish, and applied scroll decoration add variety to an otherwise simple wash bowl of the late nineteenth century. The bowl is taller in the back and slopes forward at the handles. The pitcher has a deep, full body, a rather short pouring spout, and a handle notched for a firm grip.

WASH BOWL and PITCHER

S. Bell & Son, Strasburg, Virginia, late 19th century
Redware; height 12 inches (30.48 cm.)
Private Collection

In contrast to the bowl shown in plate 33, the handsomely glazed wash bowl of this set is devoid of applied decoration. The pitcher is similar to the one in Plate 33, although the handle is notched differently and the mouth is larger.

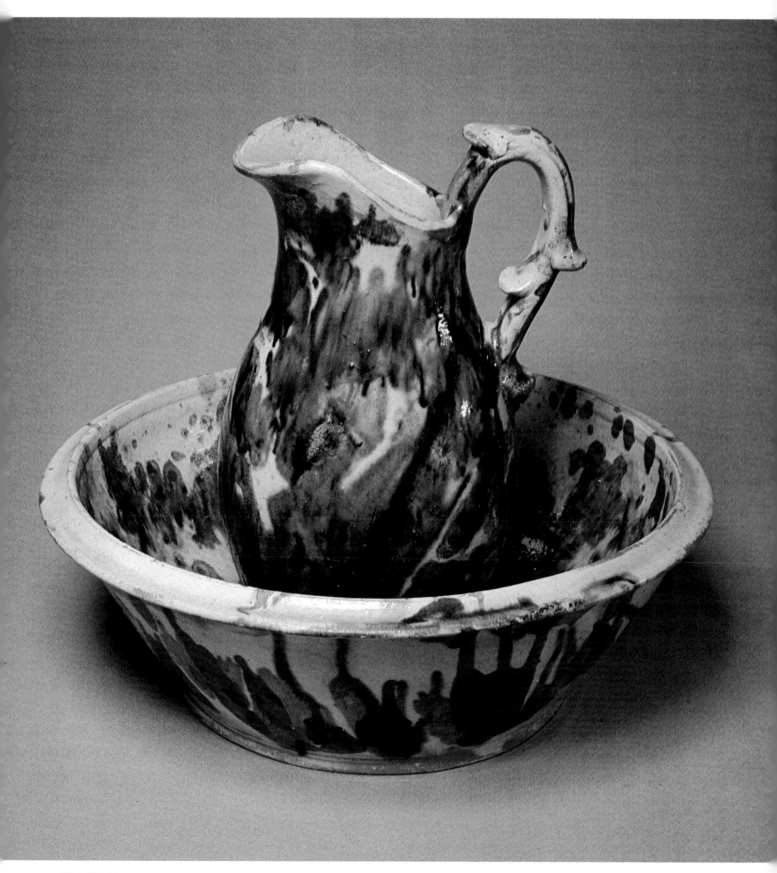

PLATE 34

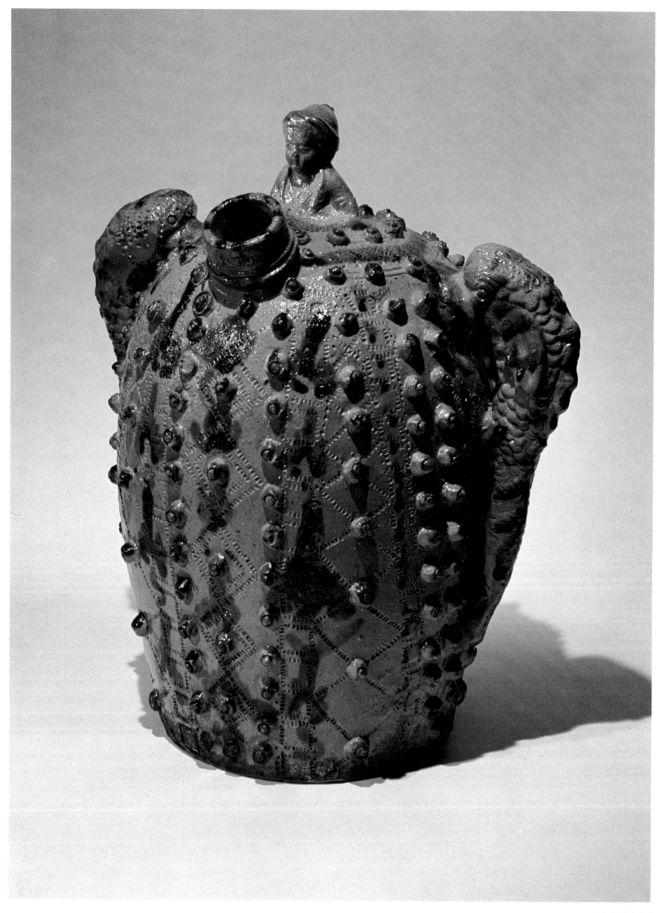

PLATE 35

WATER COOLER

Attributed to Richard Franklin (Polk) Bell, Strasburg, Virginia,
 late 19th century
Stoneware; height 14½ inches (36.83 cm.)
Courtesy The Metropolitan Museum of Art, New York,
 Gift of Mrs. Robert W. de Forest, 1933

This stoneware water cooler is an unusual and highly personal artistic statement. Most noticeable are the applied buttons that cover the entire surface. The delicate coggling on the body forms a square-and-diamond pattern. Traditional cobalt blue coloring is also freely used. The finial of a boy's torso and head is also an important feature. This figure appears to be from a mold very similar to the one used for the molded boy in Plate 4. The dolphin-shaped handles have also been seen on the vases in Plate 13.

WATER COOLER

Solomon Bell, Strasburg, Virginia, late 19th century
Mark: stamped, *SOLOMON BELL / STRASBURG*
Redware; height 20½ inches (52.07 cm.)
Private Collection

The applied decoration on this water cooler shows a man flanked by rearing lions, perhaps a Biblical depiction of Daniel. Lion's heads are used also as handles. The stamp of Solomon Bell is plainly seen above the center relief. For height and convenience, an earthenware stand was provided.

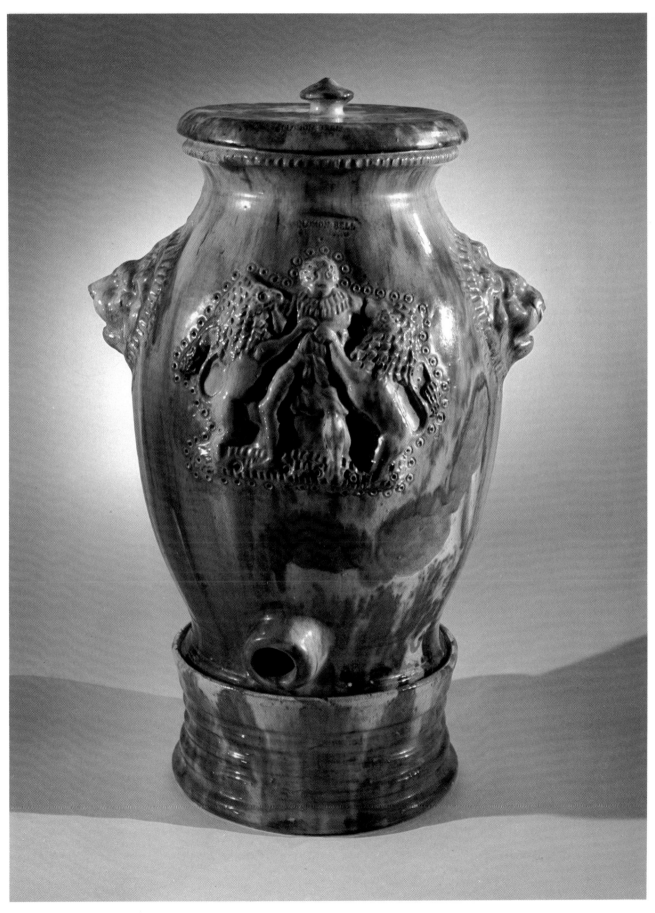

PLATE 36

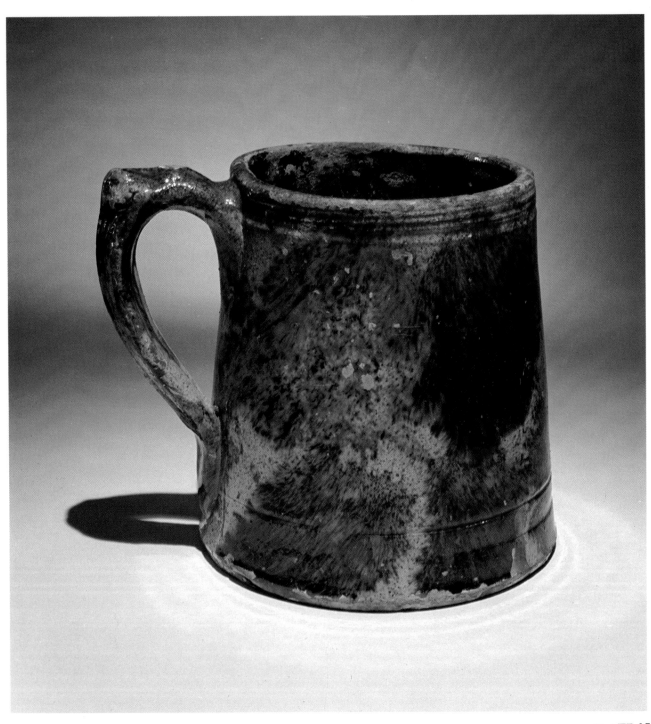

PLATE 37

LARGE MUG

S. Bell & Son, Strasburg, Virginia, late 19th century
Mark: stamped, *S. BELL & SON / STRASBURG*
Redware; height 7 inches (17.78 cm.)
Courtesy Henry Ford Museum, Dearborn, Michigan

Large mugs such as this are scarce. A mottled glaze covers large areas and
gives a textured appearance; the rim and base are incised with banding.

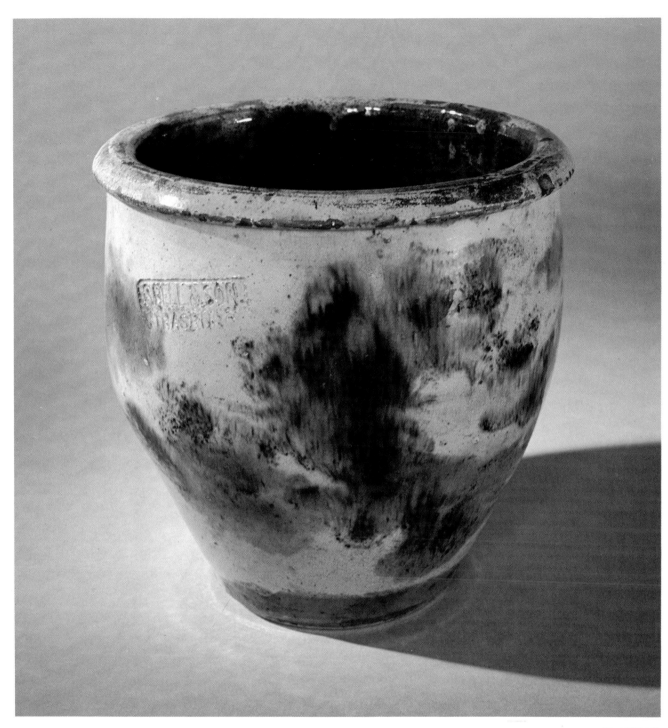

PLATE 38

CROCK

S. Bell & Son, Strasburg, Virginia; late 19th century
Mark: stamped, *S. BELL & SON / STRASBURG*
Redware; height 8 inches (20.32 cm.)
Private Collection

This crock contains many of the elements characteristic of Bell pottery.
The glaze of chocolate brown and green on a white slip ground, and the
simple, solid construction are typically Bell.

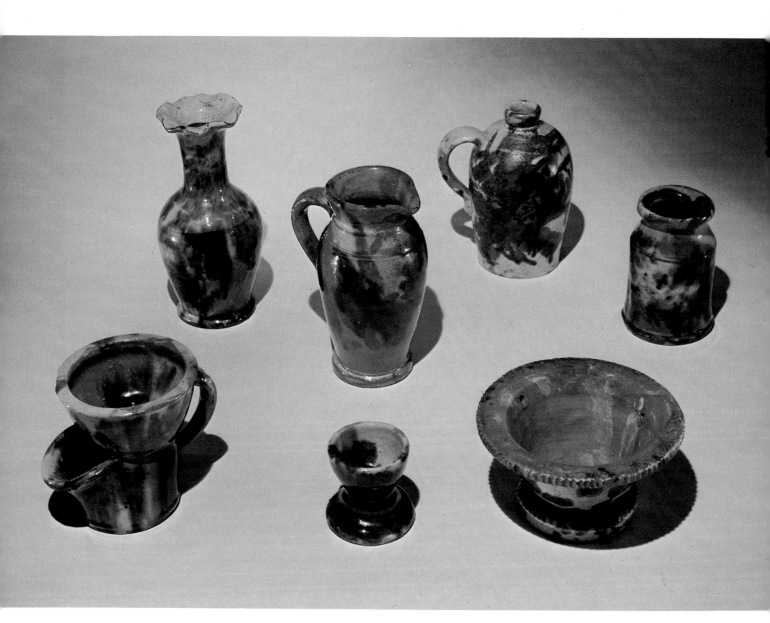

PLATE 39

HOLLOWARE GROUP

JAR
Attributed to S. Bell & Son, Strasburg, Virginia, late 19th century
Redware; height 5 inches (12.70 cm.)
Private Collection

HANGING FLOWER BASKET
Attributed to S. Bell & Son, Strasburg, Virginia, late 19th century
Redware; height 3¾ inches (9.53 cm.)
Private Collection

JUG
Attributed to S. Bell & Son, Strasburg, Virginia, late 19th century
Redware; height 7 inches (17.78 cm.)
Private Collection

EGG CUP
Attributed to S. Bell & Son, Strasburg, Virginia, late 19th century
Redware; height 2½ inches (6.35 cm.)
Private Collection

PITCHER
Attributed to S. Bell & Son, Strasburg, Virginia, late 19th century
Redware; height 7 inches (17.78 cm.)
Private Collection

VASE
Attributed to S. Bell & Son, Strasburg, Virginia, late 19th century
Redware; height 8½ inches (21.59 cm.)
Private Collection

SHAVING MUG
Attributed to S. Bell & Son, Strasburg, Virginia, late 19th century
Redware; height 4¾ inches (12.07 cm.)
Private Collection

A consistency in the use of mottled glazes distinguishes this holloware group. The bold use of color strengthens the appeal of the pieces.

IV

THE EBERLY POTTERS
Active 1870-1905

FIGURAL GROUP

Begerly and Fleet of the Eberly Pottery, Strasburg, Virginia, 1894
Mark: incised on roof, *FROM / FISHER'S HILL / BATTLE FIELDS / SEPT. 1864*
Redware; height 15¼ inches (38.74 cm.)
Private Collection

Levi Begerly and Theodore Fleet, employed by the Eberly pottery in Strasburg, produced two known cabin scenes. Unusual and extremely important, they were done to commemorate the Battle of Fisher's Hill on the thirtieth anniversary of that event. As in the cabin of Plate 41, this example contains the inscription "From Fisher's Hill Battle Fields, Sept. 1864" incised in the roof tiles. The front portion, which contained a well and the potter's mark, has been lost.

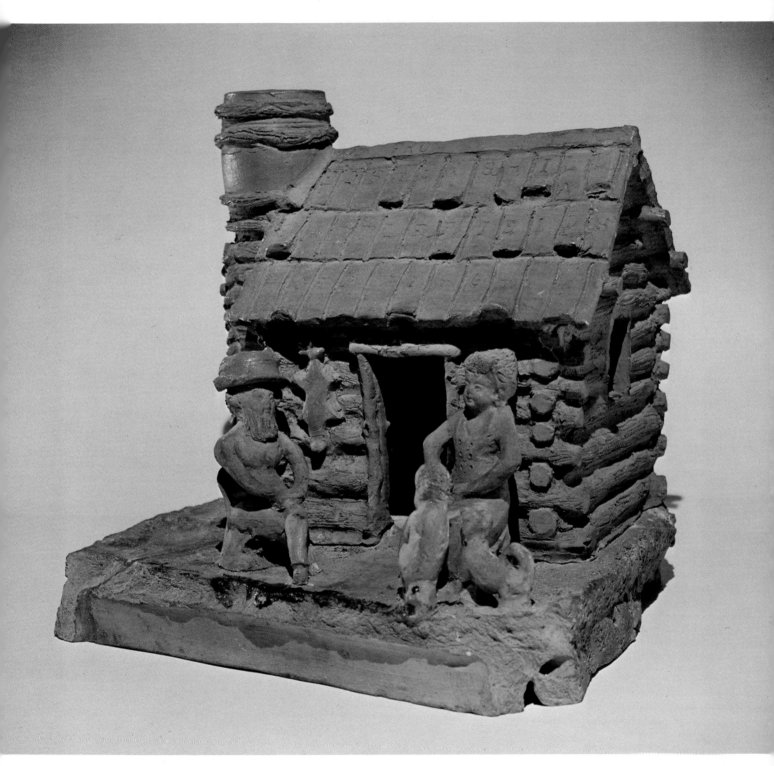

PLATE 40

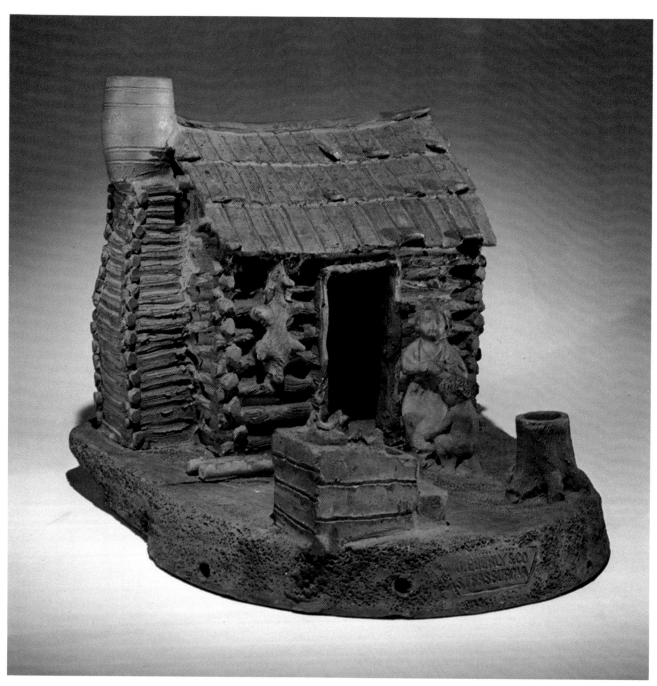

PLATE 41

FIGURAL GROUP

Begerly and Fleet of the Eberly Pottery, Strasburg, Virginia, 1894
Marks: stamped, *J. EBERLY & CO. / STRASBURG, VA.*; incised on
roof, *FROM / FISHER'S HILL / BATTLE FIELDS / SEPT. 1864*
Redware; height 15½ inches (39.37 cm.)
Courtesy Henry Ford Museum, Dearborn, Michigan

This cabin scene, as well as the one in the previous plate, was made in
separate parts and then assembled. The figure of the man is missing, yet the
rest of the family group remains intact.

FLOWER URN *with* BIRD-WING HANDLES

J. Eberly & Bro., Strasburg, Virginia, late 19th century
Mark: stamped, *J. EBERLY & BRO. / STRASBURG, VA.*
Redware; height 14 inches (35.56 cm.)
Private Collection

This urn has bird-wing handles and a peculiarly irregular rim. The serpentine foliage is raised, incised, and accented with brown glaze. Delicate leaves of white slip decorate the neck, and banding appears under the applied decoration.

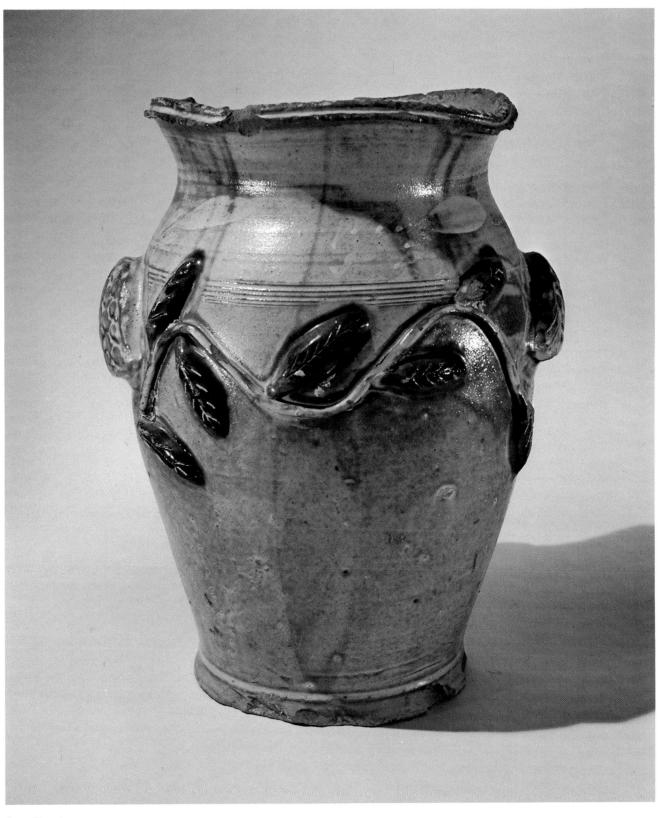

PLATE 42

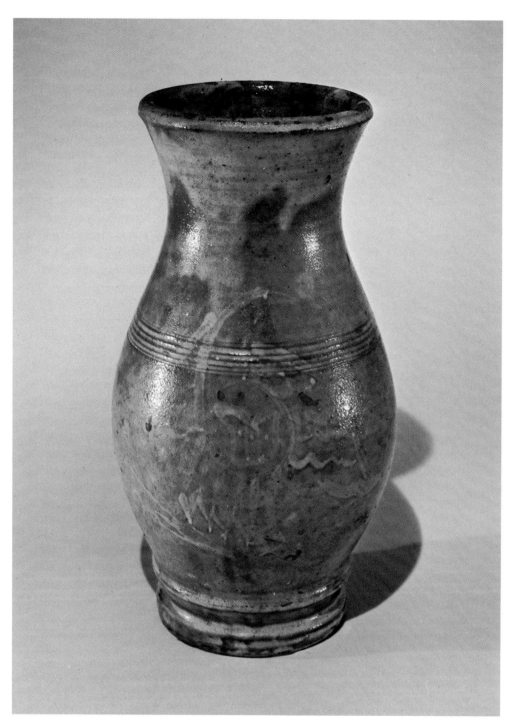

PLATE 43

VASE

Attributed to J. Eberly & Co., Strasburg, Virginia, late 19th century
Redware; height 10 inches (25.40 cm.)
Private Collection

Close banding on the upper portion of this holloware vase is very similar to
the bird-wing urn of Plate 42, a known product of the Eberly pottery.
White slip covers the neck and faintly delineates a spread-winged eagle on
the body.

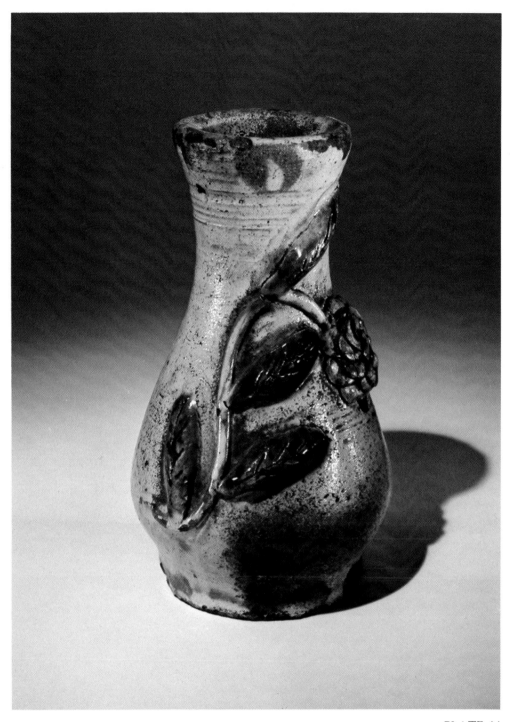

PLATE 44

VASE

Attributed to J. Eberly & Co., Strasburg, Virginia, late 19th century
Redware; height 7¼ inches (18.42 cm.)
Private Collection

A branch with foliage and flower, applied in relief, decorates this rather
small vase from the Eberly pottery. The decoration is emphasized by the
use of dark glazing over a lighter ground, such as also seen in Plates 42 and
45. The surface is rough and the white slip underglaze is unevenly applied,
revealing areas of earthenware.

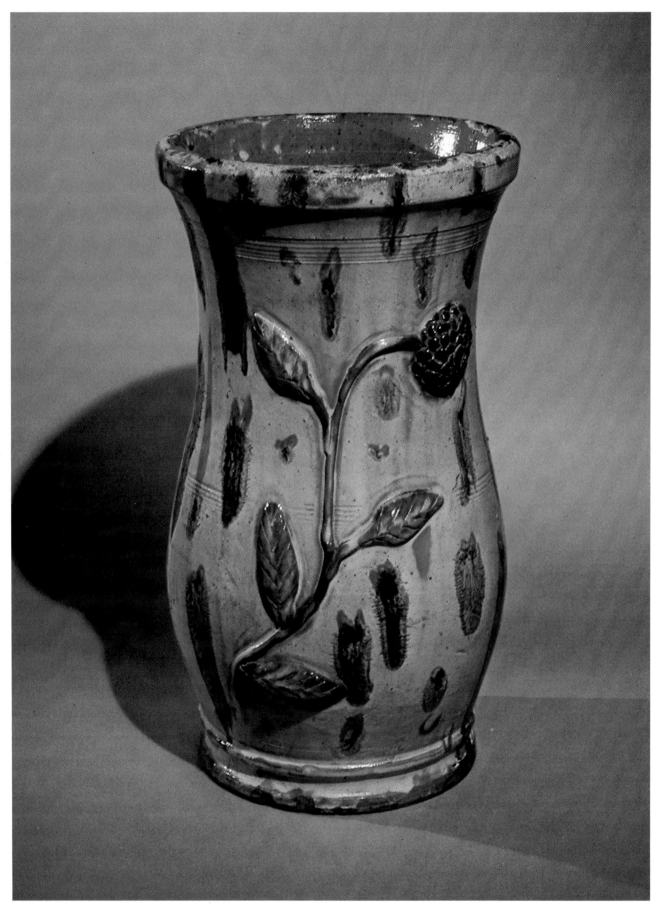

PLATE 45

UMBRELLA STAND

Attributed to J. Eberly & Co., Strasburg, Virginia, late 19th century
Redware; height 14½ inches (36.83 cm.)
Courtesy Mr. and Mrs. John Gordon

This umbrella stand reflects the popularity of the flower-and-leaf motif in combination with brown and green glazing. The body is covered with a thinly applied white slip. Its pleasing proportions, as well as the effective decoration, make this an outstanding product of the Eberly pottery.

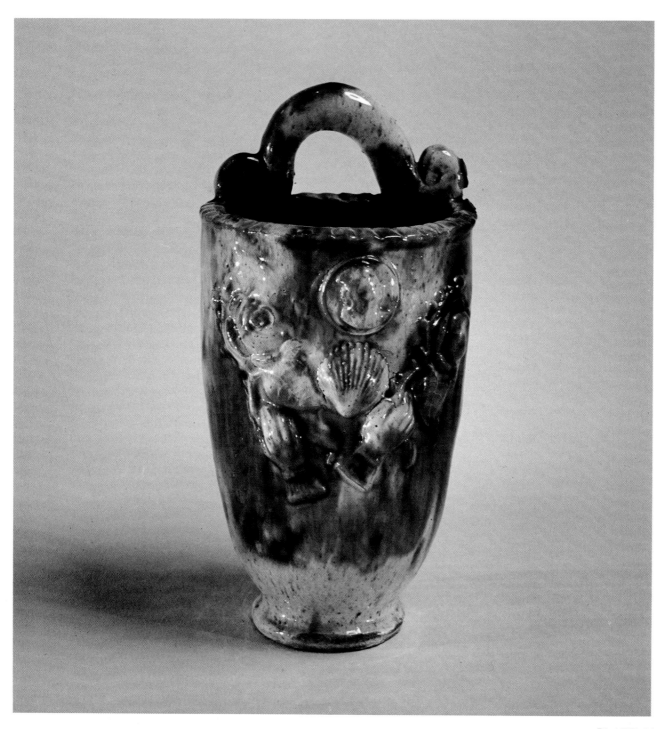

PLATE 46

WALL FLOWER HOLDER

Attributed to J. Eberly & Co., Strasburg, Virginia, late 19th century
Redware; height 7¼ inches (18.42 cm.)
Private Collection

The symbols are intriguing in this late nineteenth-century wall flower holder: hands holding a garland of roses, a seashell, and a cameo profile of a woman. Note the pie-crust incised upper rim and the scroll handle, both of which are typical of Valley wall pockets.

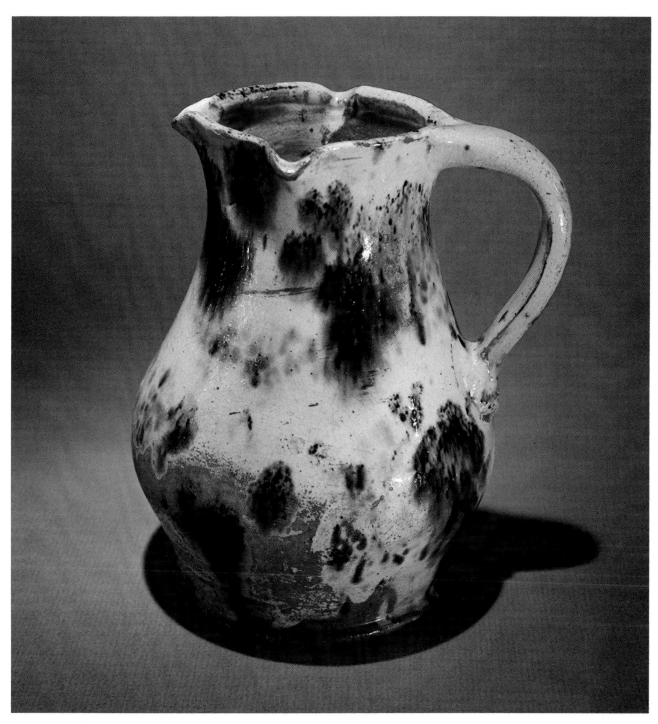

PLATE 47

PITCHER

Attributed to J. Eberly & Co., Strasburg, Virginia, late 19th century
Redware; height 7¼ inches (18.42 cm.)
Private Collection

This pitcher is unusual because of its three pouring spouts. The glazing was rather carelessly applied, illustrating that the glazing of Eberly pottery was not as consistent in quality as that of Bell pottery.

V

ANTHONY W. BAECHER
1824-1889

VASE

Anthony W. Baecher, Pennsylvania, 1850
Mark: incised in script, *Anthony / W. Bacher* / 1850*
Redware; height 5¾ inches (14.61 cm.)
Private Collection

This dated piece by Baecher was produced only two years after his immig-
ration to the United States and is reminiscent of Germanic ware of the
period. The applied flowers, foliage and birds were to be repeated as
decoration on various other holloware pieces. Much of his material was
signed, and he maintained a consistently high quality of craftsmanship.

*This vase is signed with the Germanic spelling of Bacher. At a later date, he Anglicized it
to Baecher.

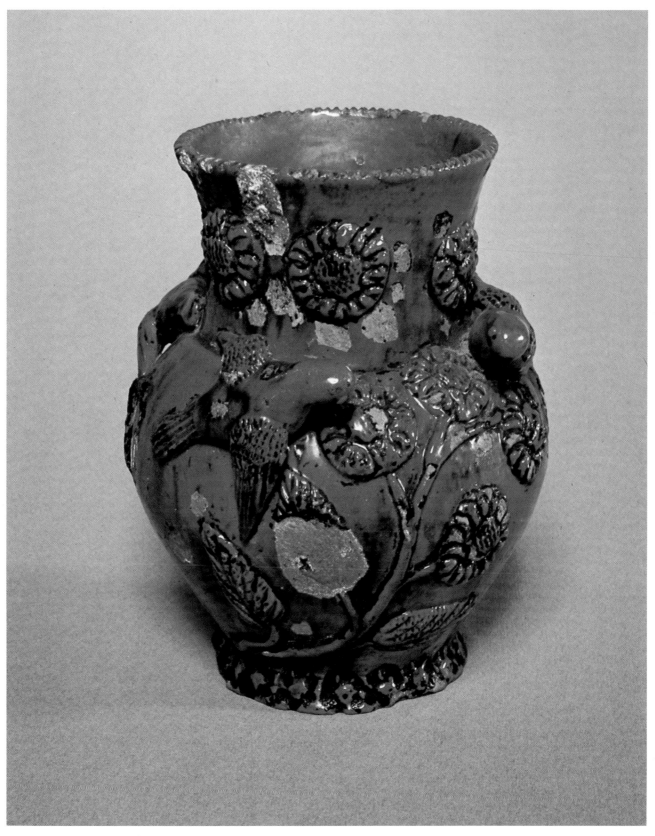

PLATE 48

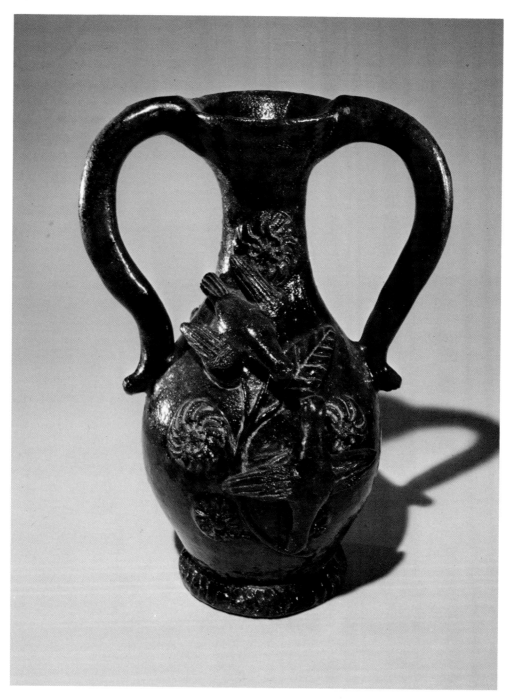

PLATE 49

VASE

Anthony W. Baecher, Thurmont, Maryland, mid 19th century
Mark: incised in script, *A.W. Bacher*
Redware; height 8½ inches (21.59 cm.)
Private Collection

Baecher's fertile imagination is evident in this delightful vase, which has
dramatic handles attached to the rim. Characteristic pinwheel flowers are
prominent in low relief, with feeding birds in sculptural relief.

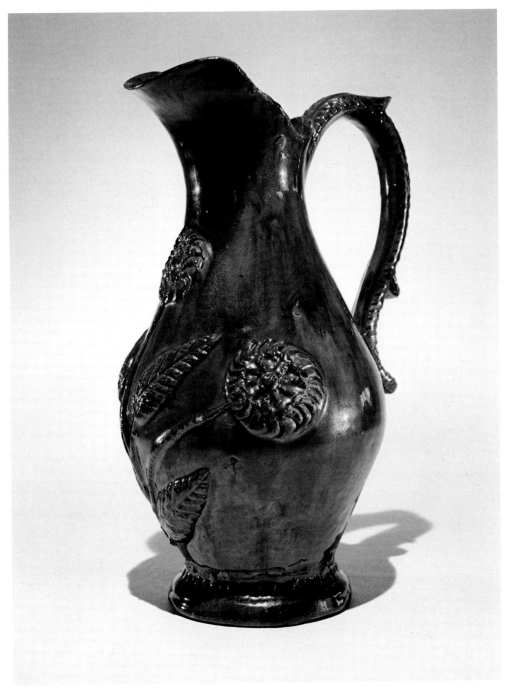

PLATE 50

WATER PITCHER

Anthony W. Baecher, Winchester, Virginia, late 19th century
Mark: incised in script, *Anthony / Bacher*
Redware; height 10 inches (25.40 cm.)
Private Collection

Many of Baecher's decorative motifs were used throughout his career. This late nineteenth-century example is interesting in comparison to earlier pieces, shown in Plates 48 and 49. The floral relief becomes more refined in the later work, but the links to earlier style are unmistakable.

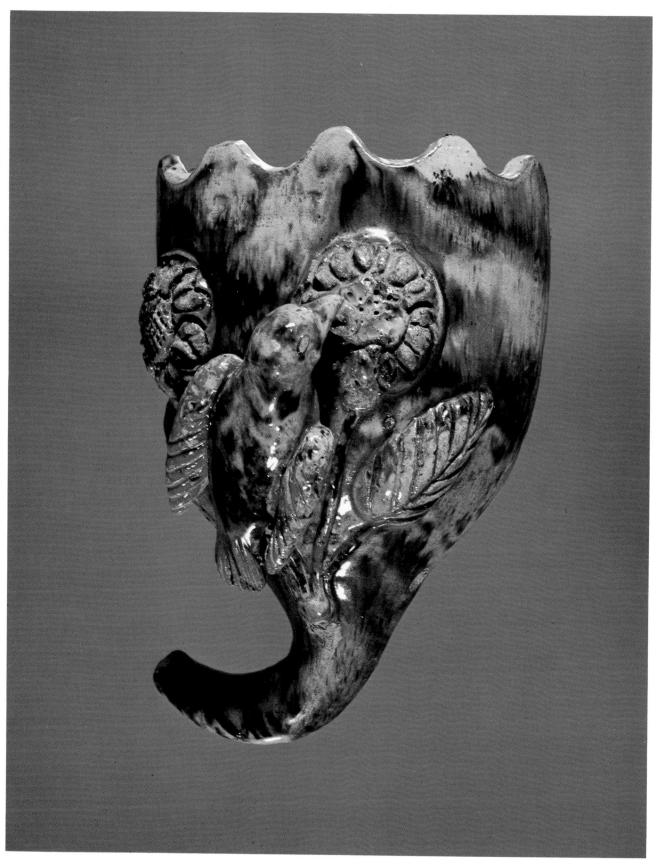

PLATE 51

104

WALL FLOWER HOLDER

Anthony W. Baecher, Winchester, Virginia, late 19th century
Mark: stamped, *BAECHER / WINCHESTER*
Redware; height 7 inches (17.78 cm.)
Private Collection

In contrast to Valley flower holders already shown, this one is based on the cornucopia. The upper rim is deeply scalloped, and the decoration features a bird holding a worm in its beak.

VASE

Anthony W. Baecher, Winchester, Virginia, 1887
Mark: incised in script, *A.W. / Bacher / 1887*
Redware; height 6¼ inches (15.88 cm.)
Private Collection

This late and innovative work by Baecher incorporates twisting vines and coleslaw applied to the body. Coleslaw is an unusual feature in nonsculptural pottery.

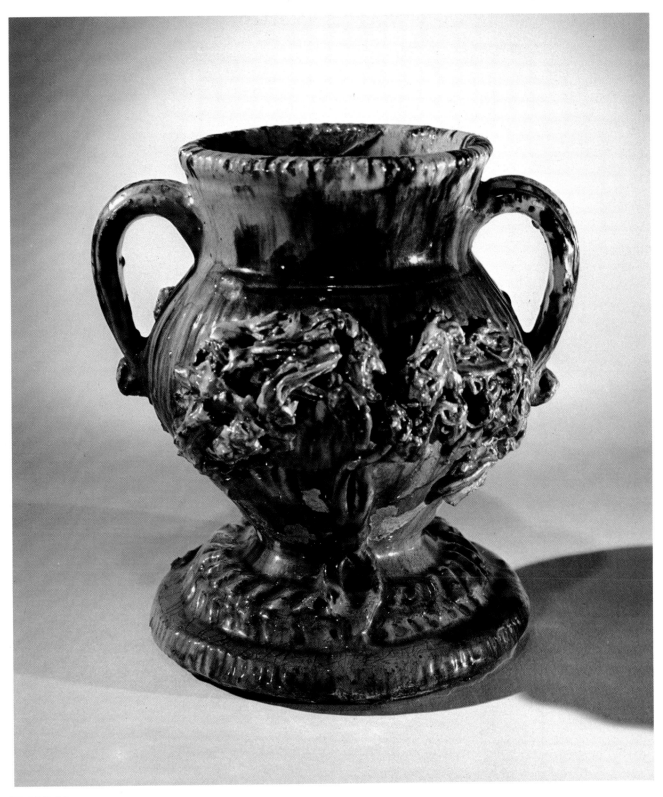

PLATE 52

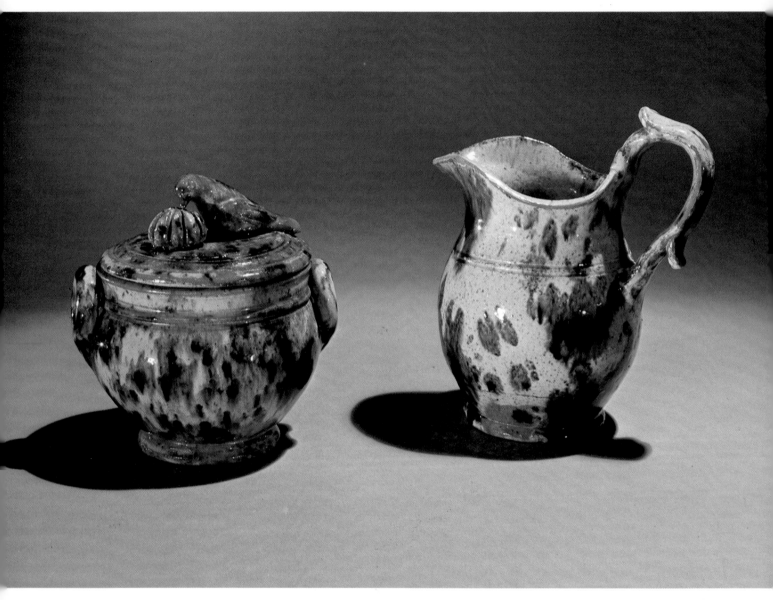

PLATE 53

SUGAR BOWL

Anthony W. Baecher, Winchester, Virginia, late 19th century
Mark: stamped, *BAECHER, WINCHESTER*
Redware; height 5¾ inches (14.61 cm.)
Courtesy Henry Ford Museum, Dearborn, Michigan

PITCHER

Anthony W. Baecher, Winchester, Virginia, late 19th century
Mark: incised on bottom, *BAECHER*
Redware; height 7¼ inches (18.42 cm.)
Courtesy Henry Ford Museum, Dearborn, Michigan

Another feeding bird serves as the finial of the sugar-bowl lid. The bowl and creamer complement each other handsomely in shape and glaze. It is rare to find a sugar bowl and creamer still intact.

FIGURE of a GOAT

Anthony W. Baecher, Winchester, Virginia, late 19th century
Mark: stamped, *BAECHER / WINCHESTER*
Redware; height 8½ inches, length 6½ inches (21.59 by 16.51 cm.)
Private Collection

This rare seated goat boasts impressive horns that are both graceful and
formidable. The piece demonstrates the humor and originality that are the
essence of Valley sculpture.

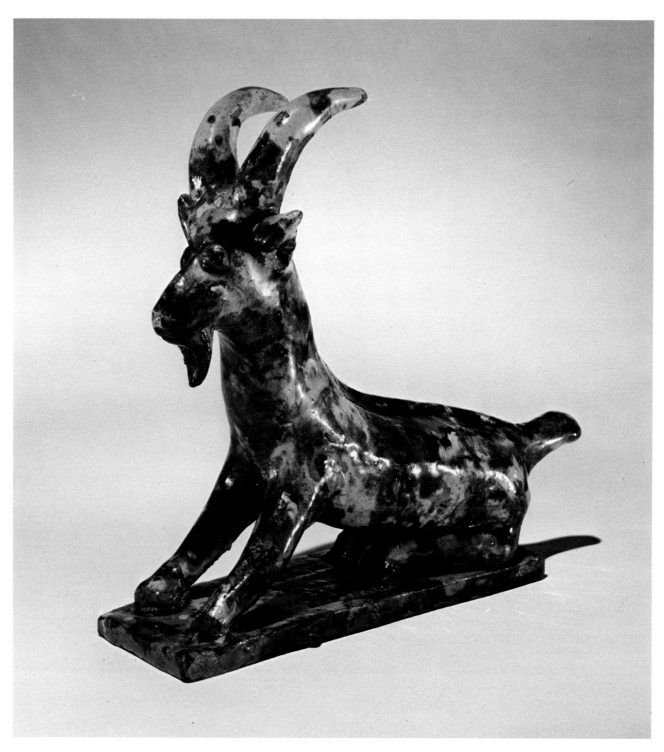

PLATE 54

FIGURE of a SEATED MAN

Attributed to Anthony W. Baecher, Winchester, Virginia, late 19th century
Redware; height 19 inches (48.26 cm.)
Courtesy New York State Historical Association, Cooperstown, New York

Again, humor is apparent in this seated man. The beard, hair, and face are modeled and painted to convey a more natural quality. The identity of the subject is not known, although it could be a self-portrait, since Baecher had a beard and thick, curly hair. The base and tree-stump support are of wood.

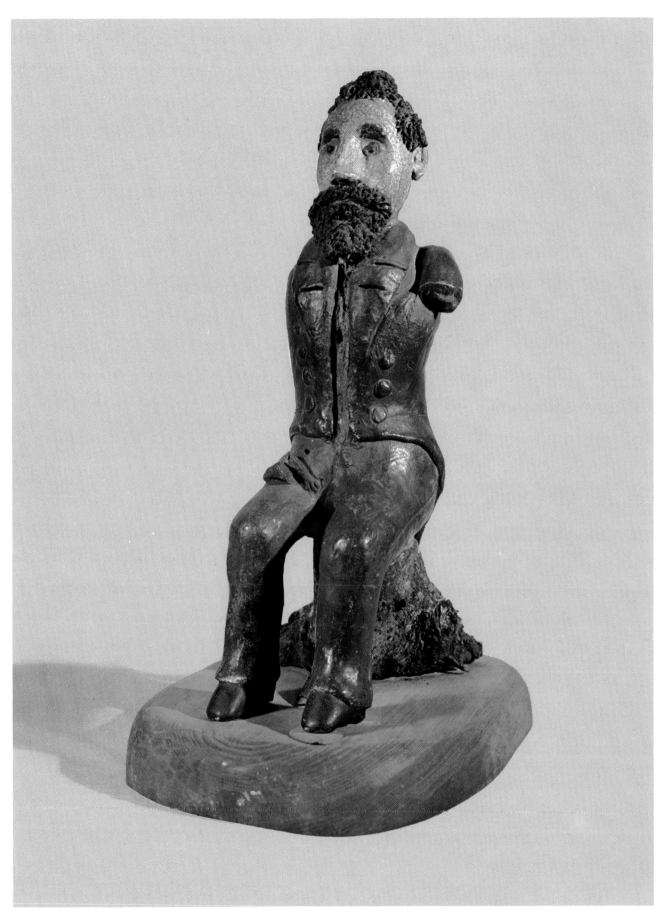

PLATE 55

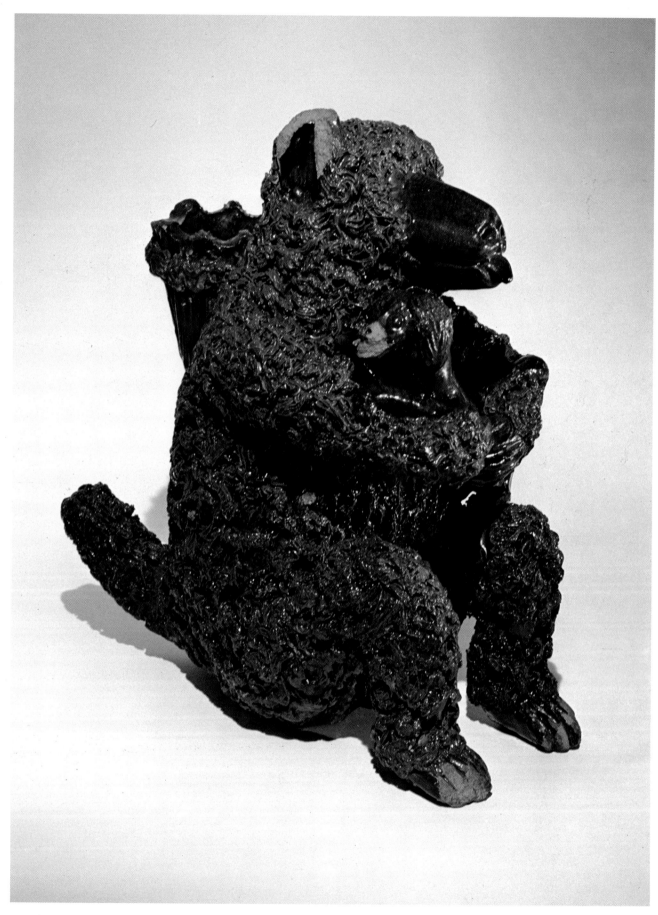

PLATE 56

FIGURE of a BEAR HOLDING a DOG

Attributed to Anthony W. Baecher, Winchester, Virginia, late 19th century
Redware; height 12½ inches (31.75 cm.)
Courtesy Abby Aldrich Rockefeller Folk Art Collection, Williamsburg, Virginia

This comical, seated bear sticks out his tongue at the viewer while holding a dog in his arms; he wears a flower basket on his back. Glazed in chocolate brown, the bear's coat is made of clay coleslaw.

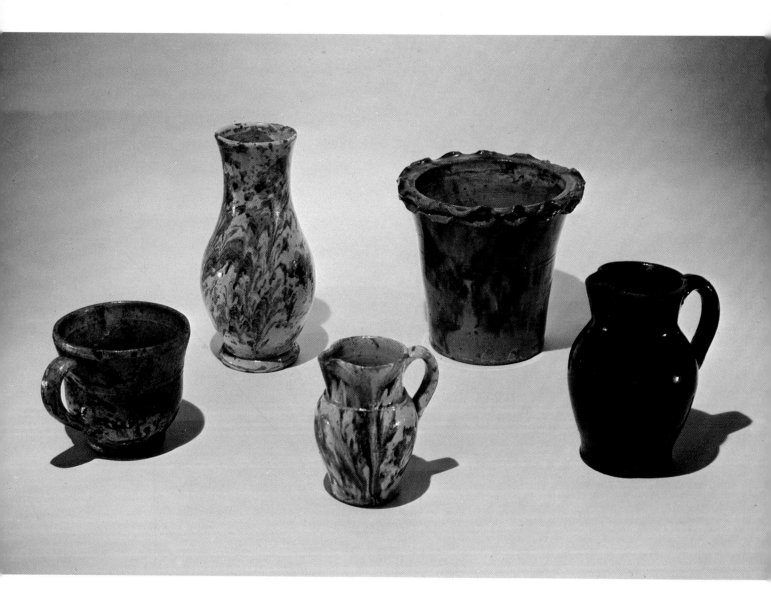

PLATE 57

HOLLOWARE GROUP

CUP
Anthony W. Baecher, Winchester, Virginia, late 19th century
Mark: stamped, *Bacher*
Redware; height 4 inches (10.16 cm.)
Courtesy Bob Rose, Front Royal, Virginia

VASE
Anthony W. Baecher, Winchester, Virginia, late 19th century
Mark: stamped, *BAECHER / WINCHESTER*
Redware; height 8½ inches (21.59 cm.)
Courtesy Bob Rose, Front Royal, Virginia

SMALL PITCHER
Anthony W. Baecher, Winchester, Virginia, late 19th century
Mark: stamped, *BAECHER / WINCHESTER*
Redware; height 7 inches (17.78 cm.)
Courtesy Bob Rose, Front Royal, Virginia

FLOWER POT
Anthony W. Baecher, Winchester, Virginia, late 19th century
Mark: stamped, *BAECHER / WINCHESTER*
Redware; height 7 inches (17.78 cm.)
Courtesy Bob Rose, Front Royal, Virginia

PITCHER
Attributed to Anthony W. Baecher, Winchester, Virginia late 19th century
Redware; height 6 inches (15.24 cm.)
Courtesy Bob Rose, Front Royal, Virginia

Baecher's individuality is also evident in these pieces of daily ware. The marble pattern is particularly effective on the vase and small pitcher. The ebony pitcher at the far right requires no embellishment to support its simple elegance.

VI

JOHN GEORGE SCHWEINFURT
1825-1907

BANK

Attributed to John George Schweinfurt,* New Market, Virginia,
 mid 19th century
Redware; height 10¼ inches (26.04 cm.)
Courtesy Henry I. Tusing, New Market, Virginia

This masterpiece of earthenware craftsmanship and fantasy is a child's bank. It could possibly be a replica of the artist's kiln. Four chimneys lead to the roof, where a boy looks into the coin slot and a bird perches above him. Spanning the roof is an entwined basket handle spaced with flowers. An outer wall encircles the base. (See Plate 59 for a rear view.)

*This bank, as well as the pieces shown in Plate 60, remain in the Schweinfurt family.

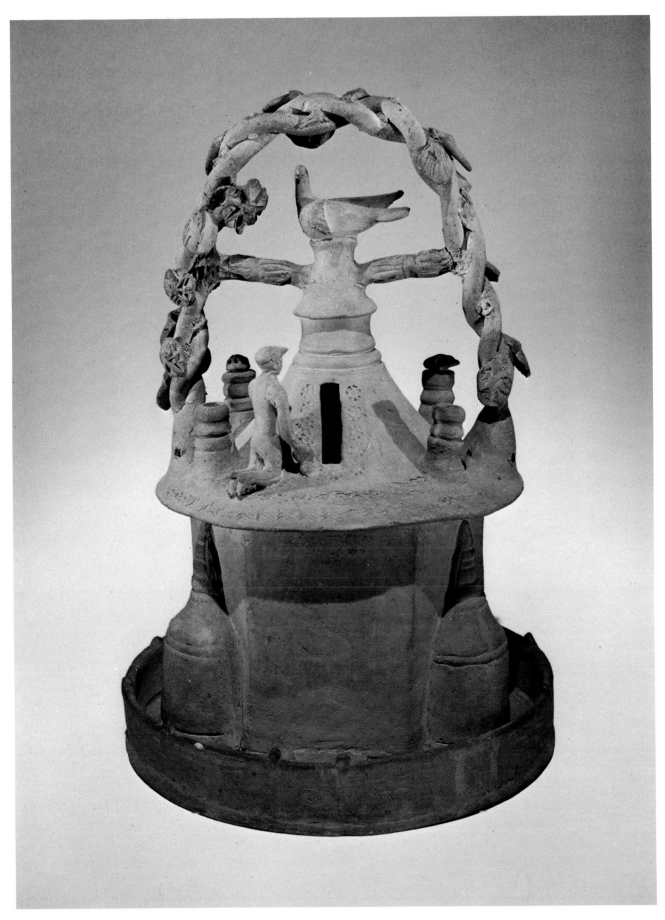

PLATE 58

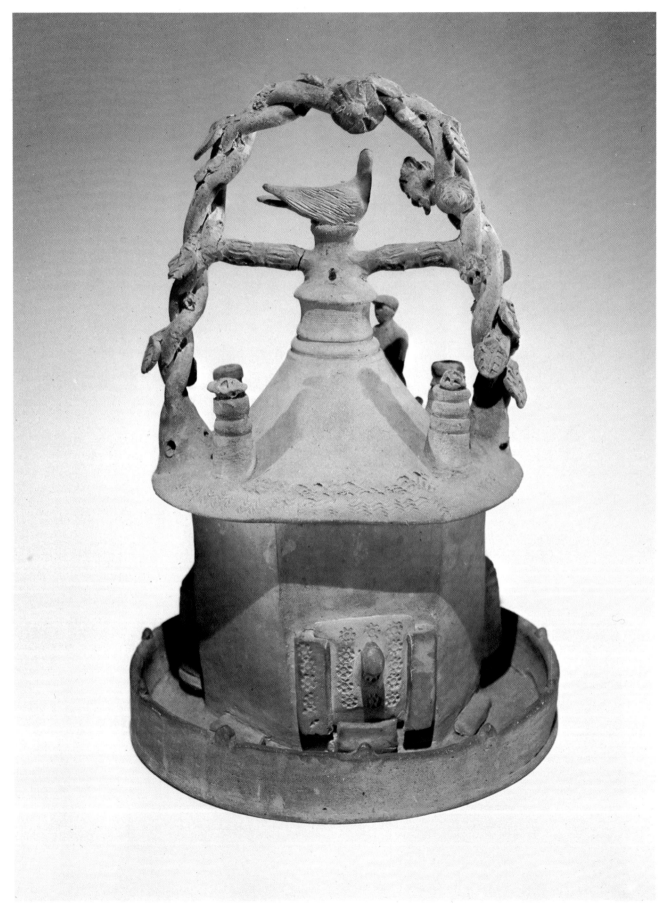

PLATE 59

BANK (back)

Attributed to John George Schweinfurt, New Market, Virginia, mid 19th century
Redware; height 10¼ inches (26.04 cm.)
Courtesy Henry I. Tusing, New Market, Virginia

The sliding door, which was intended for retrieving coins, is reminiscent of the door to a kiln.

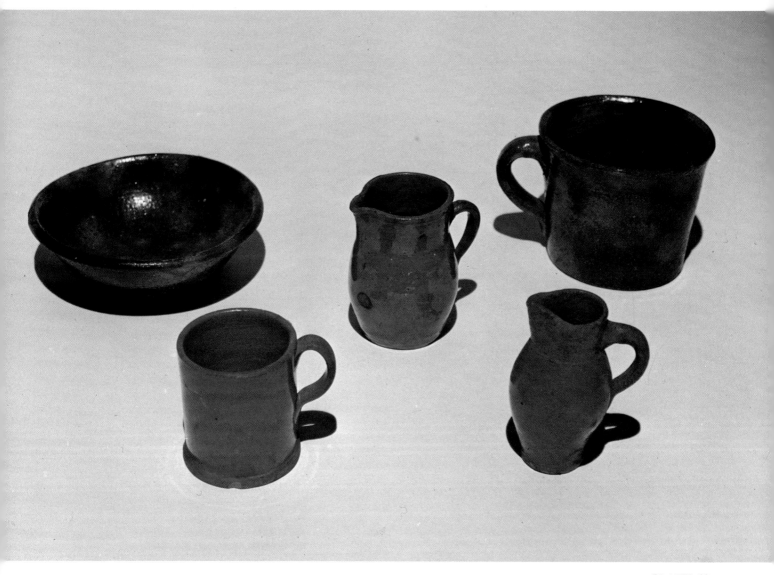

PLATE 60

HOLLOWARE GROUP

BOWL
Attributed to John George Schweinfurt, New Market, Virginia, mid 19th century
Redware; height 2 inches, diameter 5 inches (5.08 by 12.70 cm.)
Courtesy Henry I. Tusing, New Market, Virginia

SMALL MUG
Attributed to John George Schweinfurt, New Market Virginia, mid 19th century
Redware; height 2 inches (5.08 cm.)
Courtesy Henry I. Tusing, New Market, Virginia

PITCHER
Attributed to John George Schweinfurt, New Market, Virginia, mid 19th century
Redware; height 2¾ inches (6.99 cm.)
Courtesy Henry I. Tusing, New Market, Virginia

SMALL PITCHER
Attributed to John George Schweinfurt, New Market, Virginia, mid 19th century
Redware; height 3 inches (7.62 cm.)
Courtesy Henry I. Tusing, New Market, Virginia

MUG
Attributed to John George Schweinfurt, New Market, Virginia, mid 19th century
Redware; height 3 inches (7.62 cm.)
Courtesy Henry I. Tusing, New Market, Virginia

The strength of this group is in the simplicity of the shapes. Only the small pitcher (second from the right) appears top-heavy for the size of the base. The mug (far right) gently tapers upward and is enhanced by the gradations of color in the glaze. The olive glaze with orange spots that appears on some pieces was caused by kiln conditions and is repeated in other Schweinfurt pottery.

APPENDIX

MARKS
All marks were stamped, except those designated "in script."
These were written in the moist clay with a pointed instrument.

PETER BELL, Winchester, Virginia, active 1824-1845
> *P. Bell*

JOHN BELL, Winchester, Virginia, active 1824-1827
> *J. Bell* (raised letters)

JOHN BELL, Chambersburg, Pennsylvania, active 1827-1833
> *J. Bell*

JOHN BELL, Waynesboro, Pennsylvania, active 1833-1880
> *J. Bell*
>
> *John Bell*
>
> *John Bell*
> *Waynesboro*

JOHN W. BELL, Waynesboro, Pennsylvania, active 1880-1895
> *John W. Bell*
> *Waynesboro, Pa.*

UPTON BELL, Waynesboro, Pennsylvania, active 1895-1899
> *Upton Bell*
> *Waynesboro*
>
> *Upton M. Bell*
> *Waynesboro, Pa.*

SAMUEL BELL, Winchester, Virginia, active 1824-1833
> *S. Bell* (raised letters)

SOLOMON BELL, Winchester, Virginia, active 1830-1837
> *Solomon Bell*
> *Winchester* (in script)

SAMUEL BELL, Strasburg, Virginia, active 1833-18?[1]
> *S. Bell*

1. The date of Samuel Bell's death is unknown.

SAMUEL and SOLOMON BELL, Strasburg, Virginia active 1837-1882

Solomon Bell

Solomon Bell (in script)

Solomon Bell
Strasburg

Solomon Bell
Strasburg, Va.

Solomon Bell
Strasburg, Va. (raised letters)

Solomon Bell
Strasburg
 Va.

SAMUEL BELL, RICHARD FRANKLIN (POLK) BELL, and
CHARLES FORREST BELL, Strasburg, Virginia, active 1882-1908

S. Bell & Sons (in script)

S. Bell & Son
Strasburg

Bell (1904-1908)

JACOB JEREMIAH EBERLY, Strasburg, Virginia, active 1880-1906

J. Eberly & Co.
Strasburg, Va.

J. Eberly & Bro.
Strasburg, Va.

From
J. Eberly & Bro.
*
Strasburg, Va.

Eberly & Son
Strasburg, Va.

ANTHONY W. BACHER,[2] Pennsylvania, active 1850-18?[3]

Anthony W. Bacher (in script)

ANTHONY W. BACHER, Thurmont, Maryland, active 18?-1880[4]

A. W. Bacher (in script)

Anthony W. Bacher (in script)

2. It is not known exactly when Baecher Anglicized the spelling of his name after his immigration to America.

3. Baecher arrived in America in 1848. The exact length of time he remained in Pennsylvania and the date of his move to Maryland are unknown.

4. John A. Baecher stated in a letter to John Baer Stoudt, dated July 29, 1929, that his father actually worked in both the Thurmont and Winchester potteries until about 1880, at which time he discontinued his interest in the Thurmont operation.

ANTHONY W. BAECHER, Winchester, Virginia, active 1868-1889

Bacher

A. W. Bacher (in script)

Anthony Bacher
Winchester (in script)

Anthony W. Bacher (in script)

Baecher (in script)

Baecher
Winchester

Baecher
Winchester, Va.

A. W. Baecher
Winchester, Va.

SAMUEL H. SONNER, Strasburg, Virginia, active 1870-1883

S. H. Sonner
Strasburg, Va.

JOHN H. SONNER, Strasburg, Virginia, active 1883-1892

J. H. Sonner
Strasburg, Va.

JEREMIAH KEISTER, Strasburg, Virginia, active 1880

J. Keister & Co.
Strasburg, Va.

AMOS KEISTER, Strasburg, Virginia, active 1885

A. Keister & Co.
Strasburg, Va.

Keister & Sonner
Strasburg, Va.

JAMES M. HICKERSON, Strasburg, Virginia, active 1884-1898

J. M. Hickerson
Strasburg, Va.

J. M. Hickerson

Strasburg, Va.

W. H. CHRISTMAN, Strasburg, Virginia

W. H. Christman
Strasburg, Va.

W. B. KENNER, Strasburg, Virginia

W. B. Kenner
Strasburg, Va.

WILLIAM H. LEHEW, Strasburg, Virginia, active 1890

W. H. Lehew & Co.
Strasburg, Va.

GEORGE W. MILLER, Strasburg, Virginia

Geo. W. Miller
Strasburg, Va.

Miller & Woodard
Strasburg, Va.

L.D. FUNKHOUSER, Strasburg, Virginia, active 1899-1905

L.D. Funkhouser & Co.
Strasburg, Va.

SELECTED BIBLIOGRAPHY

Bivins, John, Jr. *The Moravian Potters in North Carolina.* Chapel Hill, N.C.: The University of North Carolina Press, 1972.

Davis, Julia. *The Shenandoah.* New York: Farrar & Rinehart, Inc., 1945.

Guilland, Harold F. *Early American Folk Pottery.* Philadelphia: Chilton Book Company, 1971.

Hillier, Bevis. *Pottery and Porcelain 1700-1914.* Des Moines and New York: Meredith Press, 1968.

Jones, Louis C. "The Sculpture." *Antiques Magazine,* February 1959, p. 178.

Keister, E.E. *Strasburg, Virginia and The Keister Family.* Strasburg, Virginia: Shenandoah Publishing House, Inc., 1972.

Ramsay, John. *American Potters and Pottery.* Clinton, Mass.: Hale, Cushman & Flint, 1939.

Rice, A.H. and Stoudt, John Baer. *The Shenandoah Pottery.* Strasburg, Virginia: Shenandoah Publishing House, Inc., 1929.

Schwartz, Marvin D. *Collector's Guide to Antique American Ceramics.* Garden City, New York: Doubleday and Company, Inc., 1969.

Smith, Elmer L. *The Folk Art of Pennsylvania Dutchland.* Lebanon, Pennsylvania: Applied Arts Publishers, 1966.

_____. *Arts and Crafts of the Shenandoah Valley.* Lebanon, Pennsylvania: Applied Arts Publishers, 1968.

Stoudt, John Joseph. *Early Pennsylvania Arts and Crafts.* New York: Bonanza Books, 1964.

The Historical Society of York County. *Regional Aspects of American Folk Pottery.* York, Pennsylvania, 1974.

Webster, Donald Blake. *Decorated Stoneware Pottery of North America.* Rutland, Vermont: Charles E. Tuttle Company, 1971.